The Cat 8

Cat-toon 10

The Horse 12

Dalmatian 14

0000

Pets

These will be enough to get started. Avoid buying the cheapest pencils. Their leads often break off in the sharpener, even before they can be used. The leads are also generally too hard, making them difficult to see on the page.

Cheap erasers also cause problems by smudging rather than erasing. This often leaves a permanent stain on the paper. By spending a little more on art supplies in these areas, problems such as these can be avoided.

When purchasing a black marker, choose one to suit the size of your drawings. If you draw on a large scale, a thick felt-tip marker may be necessary. If you draw on a medium scale, a medium-point marker will do and if on a small scale, a 0.3mm, 0.5mm, 0.7mm or 0.8mm felt-tip marker will be the best.

The stages

Simply follow the lines drawn in orange on each stage using your B or HB pencil. The blue lines on each stage show what has already been drawn in the previous stages.

In the final stage the drawing has been outlined in black and the simple shape and wire-frame lines erased. The shapes are only there to help us build the picture. We finish the picture by drawing over the parts we need to make it look like our subject with the black marker, and then erasing all the simple shape lines.

Included here is a sketch of the butterfly fish as it would be originally drawn by an artist.

These are how all the drawings in this book were originally worked out and drawn. The orange and blue stages you see above are just a simplified version of this process. The drawing here has been made by many quick pencil strokes working over each other to make the line curve smoothly. It does not matter how messy it is as long as the artist knows the general direction of the line to follow with the black marker at the end. The pencil lines are erased and a clean outline is left. Therefore, do not be afraid to make a little mess with your B or HB pencil, as long as you do not press so hard that you cannot erase it later.

Grids made of squares are set behind each stage in this book. Make sure to draw a grid lightly on your page so it does not press into the paper and show up after being erased. Artist tips have also been added to show you some simple things that can make your drawing look great. Have fun!

3.

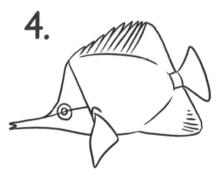

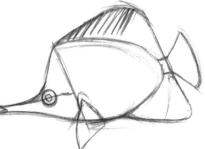

The Budgie

The budgerigar is the most popular pet bird in the world. It can be trained to learn words and repeat them in proper sequence. Budgies are an Australian native bird, however the first captive breeding took place in Europe in the 1850s.

1.

Draw a grid with three equal squares going across and four going down.

Begin with a circle near the top of the grid. Be sure to draw it in the correct position.

Draw a body shape that looks a little like a rectangle that is slightly curved on the bottom and smaller at one end.

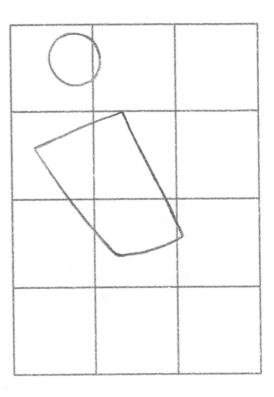

2.

Connect the head to the body with straight lines. Notice how the chest of the bird bends just inside the rectangle. This is to eliminate a sharp bend. Draw in the shape for the wing.

Draw the claws. The further set of claws appear above the nearer set. Check your drawing and move on to the next stage.

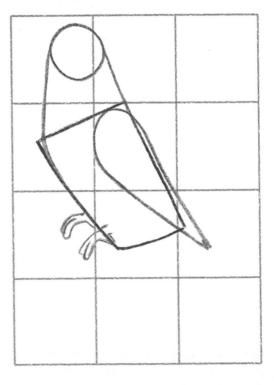

3

Draw in the beak to the left of the head circle and the eye to the right of the head circle.

Draw in a branch for the budgie to be holding onto. Starting from the back of the rectangle shape for the body, add a long slightly curved shape that comes to a rounded point for the tail feathers.

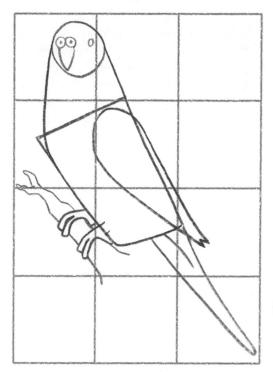

4.

Outline your artwork, erase the pencil lines and color to suit. Budgies come in many different colors and patterns. You could add your own color pattern. Be sure to do it with color pencil though, as too much black marker will darken the picture, making it look heavy.

The Cat

With around 100 different breeds, domestic cats come in many styles and colors. They are very light-footed and are able to leap seven times their body height upwards. All that exercise makes them tired and they rest about 17 hours a day.

1.

Draw a grid with three equal squares going across and four down.

Begin by drawing the shape for the body. It is basically a backwards "L" with a big long curve joining the ends together.

Draw the head circle above and to the right of the body shape.

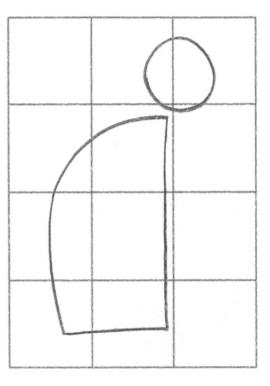

2.

Add some pointy shapes to the head shape for the ears. Draw a small circle inside and near the bottom of the head circle.

Draw an oval leaning on an angle under the head circle. This will become the chest. Join the chest to the bottom right corner of the body shape with a straight line. Check that every thing on your drawing is in the correct position and move on to the next stage.

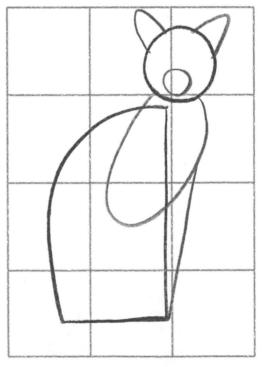

Draw leaf shapes for eyes inside the head circle and add the pupils. Draw a nose near the top of the small circle inside the head circle. Notice the mouth is a "W" shape.

Draw some lines to show the back leg curving and add in the back foot. Draw a line for the front leg and paw at the bottom. Add the other front paw outside the body shape. Draw in the back of the rear foot and the tail curving around.

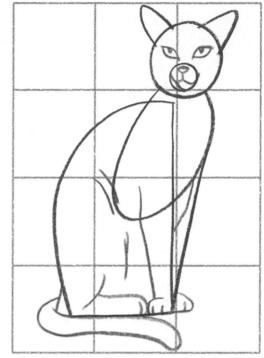

4.

Outline your cat and erase the pencil lines. Cats come in many different shapes and colors. You may like to try some different colors and patterns.

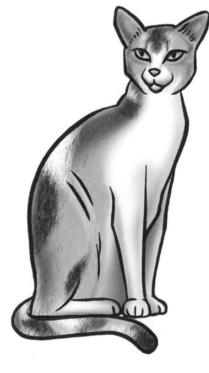

Pets

Cat-toon

Cats have big eyes and squarish bodies. The domestic cat is the only member of the cat family able to hold its tail high while walking. They can also have a wide head. By emphasising all these points we can turn our cat into a fun cartoon character. The more emphasized the features, the more "cartoony" the character.

Draw a grid with four equal squares going across and three down.

Begin with a shape like an overinflated football for the head. The top side bulges more than the bottom side.

Draw a rectangle at the bottom right side of this for the body.

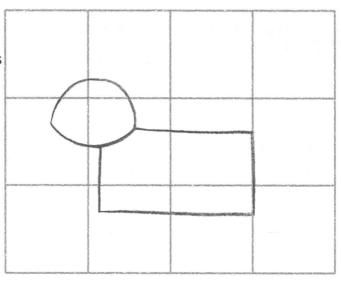

2.

Draw some ears on the head shape. Add a tail on the top corner of the rectangle.

Draw in some legs. Notice that the legs on this side of the cat come right into the rectangle shape.

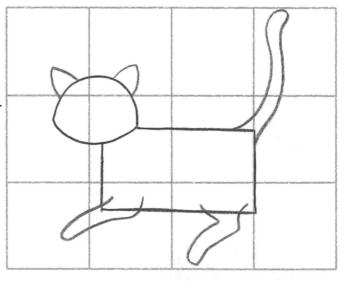

Draw in the face and neck. The bigger the eyes, the cuter the look for the character. Here we have rather large eyes.

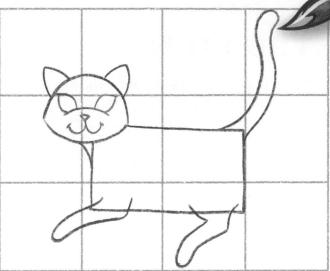

4

Draw big pupils in the eyes and draw the chin under the mouth.

Draw the legs on the other side of the body.

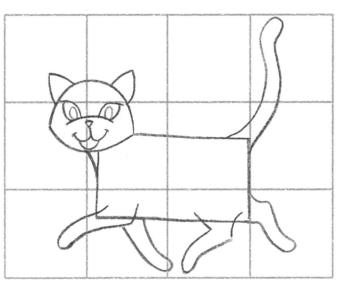

5. Outline your tabby and erase the pencil lines.

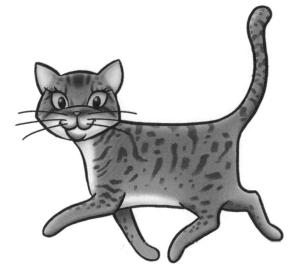

The Horse

The horse has been our helper for thousands of years. Horses were used for everything from plowing fields to general transport. Modern machinery has since replaced most of the duties that horses had to perform. Today the horse is kept for recreation purposes like trail rides and horse shows and sports like polo.

1.

Draw a square grid with three equal squares going across and three down.

Begin with a shape for the body slightly lower than the middle of the grid. Draw a circle for the head at the top left of the grid and join this to the body shape with a line.

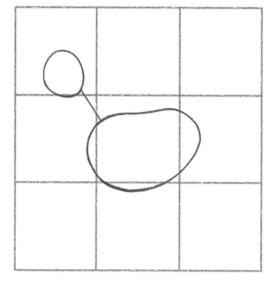

2

Draw another circle below and slightly to the left of the head circle. Join the circles to make the snout. Draw the part underneath the small circle for the chin.

Draw in the neck, making it fairly thick. Look to see where the neck attaches to the body shape. Draw in some wire-frames for the legs.

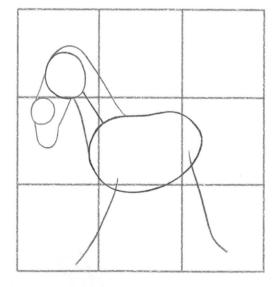

Add the ears and mane to the neck. Draw the horse's eye, mouth and nose.

Draw in the head and body shape for the girl. Draw one leg over the horse's body shape.

Add a wire-frame for the tail of the horse. Draw in the legs and knees around the leg wire-frames.

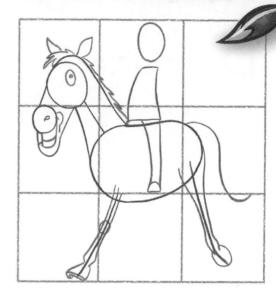

4.

Draw a wavy line for the white patch on the horse's head.

Add the girl's face, arms, hands and clothes. Draw the reins from her hands to the horse's mouth and around the horse's head.

Draw in the saddle and tail. Draw the legs on the other side of the horse. Notice they do not appear as long as the ones on this side.

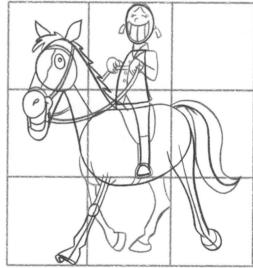

5. Outline the drawing with your marker and erase the pencil lines. This picture is quite complicated, but with a little practice this drawing technique will become second nature.

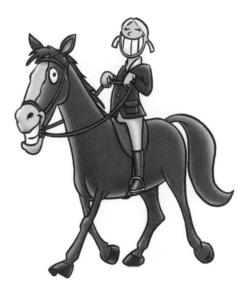

Dalmatian

The Dalmatian is a large, friendly, intelligent and energetic dog. They were originally bred for show. They would run ahead of carriages pulled by horses. They also guarded the horses in the stables when they were resting. Dalmatians are easily recognized by their black spots. They are actually born white and do not get their spots until later in life.

Draw a grid with four equal squares going across and three down.

Start with an oval for the body shape. Notice that this oval is on an angle and is smaller at one end.

2

Draw in a circle for the head and join it to the body with a wire-frame.

Add some wire-frames for legs. The back leg is curved.

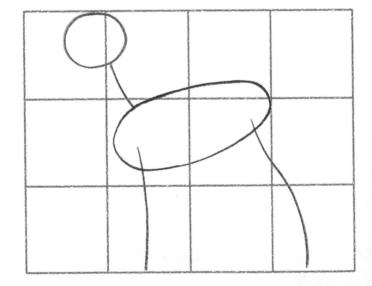

3

Draw a snout on the head circle and a triangular ear at the back of the head circle.

Draw a sharp tail at the end of the body shape. Draw legs around the wire-frames with lumps for paws at the bottom.

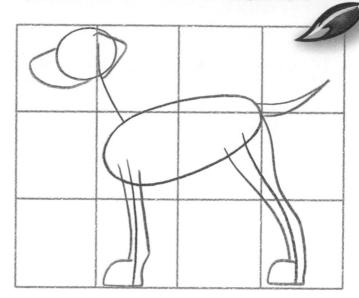

4.

Draw the mouth, eye and eye patch. The eye and eye patch are also triangle shaped. Add spots to the body.

Draw in the legs on the other side of the body, making them a little shorter. Divide up the paws with some curved lines to form toes.

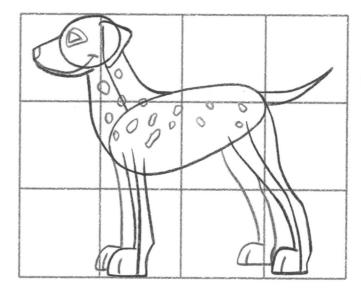

5.

Outline your dalmatian with your marker and erase the pencil lines. Dalmatians are white but can be shaded with a gray or black pencil. Notice the shading under the belly and inside the legs.

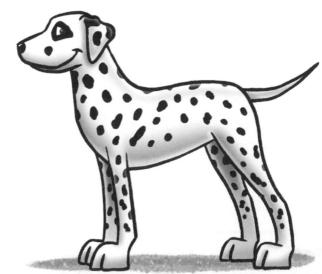

Basset Hound

The Basset Hound is a short, large-bodied dog. They were originally bred in England for hunting. With their small legs they could squeeze their way through places larger dogs could not go. Their strong sense of smell meant they could track animals very well. Basset Hounds love companionship and have lots of personality. They are patient and good with children.

Draw a grid with four equal squares going across and two down.

Begin with a shape like a jelly bean for the body and a circle for the head.

2

Add a large shape for the dog's snout onto the head shape.

Draw thick legs and big paws. The back leg lines lean toward the right before they travel down to the paws.

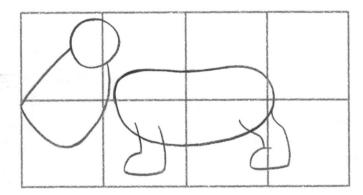

3

Draw on the neck, joining the head circle and snout to the body.

Draw in the bent, pointed tail. Add the legs on the other side of the body, making them a little smaller than the ones on this side.

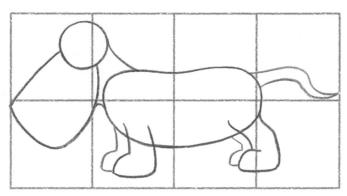

4.

Finally, draw the facial features. A Basset Hound has half-closed eyes with lots of droopy skin underneath them. Add a big smile and some long ears that reach to the ground.

Draw some lines to break up the paws.

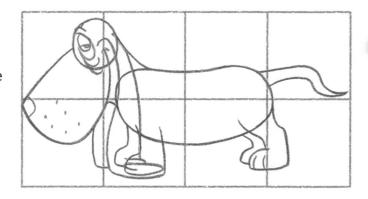

Outline your work and erase the pencil lines. When coloring, you may like to try different patches of color around the body.

The Iguana

Iguanas are reptiles. They hatch from an egg and can grow to be the length of a human adult. They are cold-blooded and must spend time in the sun to warm up. They do not respond to owners' commands like other pets. They prefer to be in a quiet and calm environment. Iguanas are able to live with other animals, but they are not playful.

1. Draw a grid with four equal squares

going across and three down.

First, draw in an oval on an angle for the body. This oval is slightly larger at the front.

2

Draw a head shape that is mostly circular, but pointed at the front. Join this to the body shape with a wire-frame.

Draw a long, pointed tail coming off the back of the body shape.

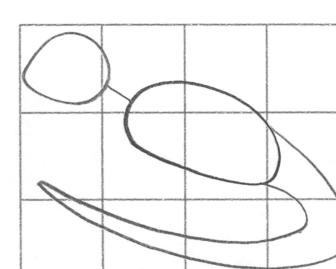

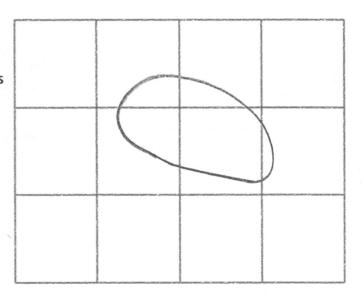

Draw the face within the head shape. Add a triangular flap under the chin. Draw in the back of the neck.

Draw a line from the top of the head to the tail above the neck and body shape. Draw the individual spines on its back to this height. Add the legs and the feet.

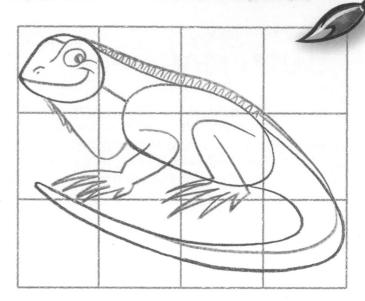

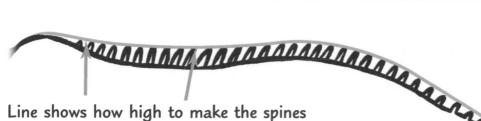

Line shows how high to make the spines

As the line gets closer to the body, the spines gradually get smaller.

Artist Tip:

Like our basic shapes, sometimes lines are used just as a guide. The line drawn above the neck that runs down to the tail is only there to show us how high the spines on the back should be. With this line as a height guide, we can simply draw the spines straight up to this height and know that when the line is erased, the drawing will look correct.

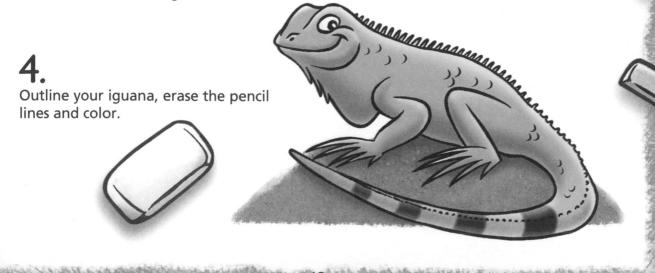

Butterfly Fish Fish The Long Nose Butterfly Fish is found in warm tropical waters around coral reefs. It uses its long nose to pick at

food pieces between delicate branches of coral where other fish cannot reach. It is a carnivore which means it only eats meat. Its favorite food is small crustaceans. It is a gentle fish that can be kept as a pet in saltwater aquariums.

Draw a grid with four equal squares going across and three down.

Begin with a shape that looks like the letter "D" leaning backward. This will make up the bulk of the body.

2.

Draw a curve around the front of the "D".

Add another line behind the "D" that has round but sharper corners. Notice where it attaches to the body underneath.

Add a long snout and an eye onto the front of the curve. Divide the head lengthways above the long nose with a straight line.

Add the fin, tail fin and a circle under the tail fin. Divide the top fin into individual spines placed almost to the corner. Draw lines for the bottom fin at the rear.

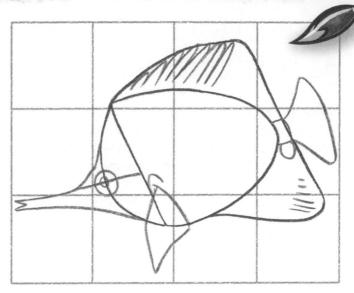

Artist Tip:

Shading can make a drawing look three dimensional. Shading is generally the underside of something where it is not in direct sunlight. When shading, use a darker hue of the same color. Here a dark yellow has been used for the shading on the lower part of the body which curves under.

Normal yellow color

21

Shaded with a darker yellow on the underside

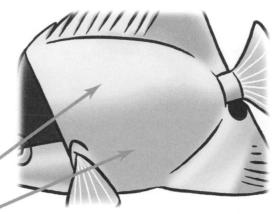

4.

Outline your drawing and erase the pencil lines. The colors are very definite on this fish. Use black and white for the head and yellow for the body.

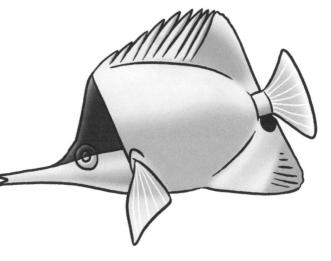

Chimpanzee

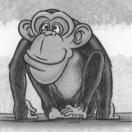

Chimps live in trees and are found in family groups. Many of these family groups living together make up a community. Chimps communicate with facial expressions and by clapping their hands. They do not have tails like monkeys but they do have large ears. They eat fruit, leaves, flowers and insects and will sometimes hunt other animals for meat. Some chimps live in santuaries where families can "adopt" them, providing money for their food and care.

1.

Draw a square grid with three equal squares going across and down.

Draw a circle left of the middle of the top of the grid for the head. Draw a big arc going from one side of the grid to the other with a flat bottom. This is the overall shape of the chimp.

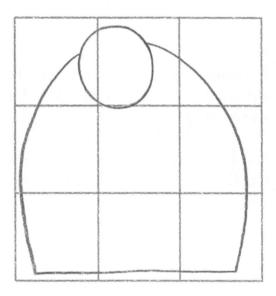

2.

Draw an oval shape below the head circle, making sure to overlap it.

Draw in the "club" shapes for the legs. The legs are bent so we only see the lower legs. Check your drawing for correct placement of shapes on the grid and move on to the next stage.

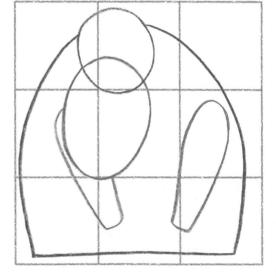

Some details can now be added. Start with the eyebrow, which overlaps the head. The mouth divides the bottom circle in half and the lips stick out of the circle.

Draw in the lines for the arms on either side of the arc. Finish this stage by drawing in shapes for the feet.

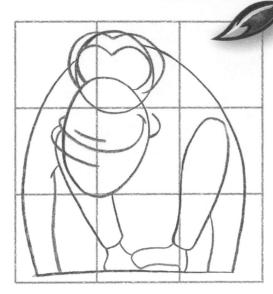

4.

Draw large ears on either side of the head. Put in the eyes and nose. The upper lip is divided with a center line.

Draw in the top of the arm on the right and the legs near the stomach. Add the hands and lines for the buttocks. Divide the feet up into toes and get your felt-tip marker ready to outline.

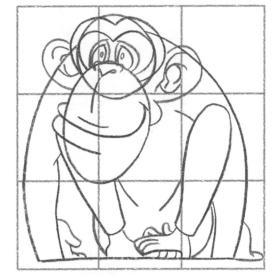

5

Chimps have dark brown or black fur. Here the fur has been colored in black with a blue/gray highlight on it as a shine. The stomach, hands and face do not have hair on them.

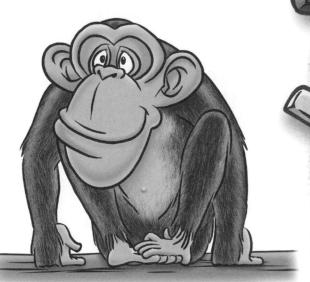

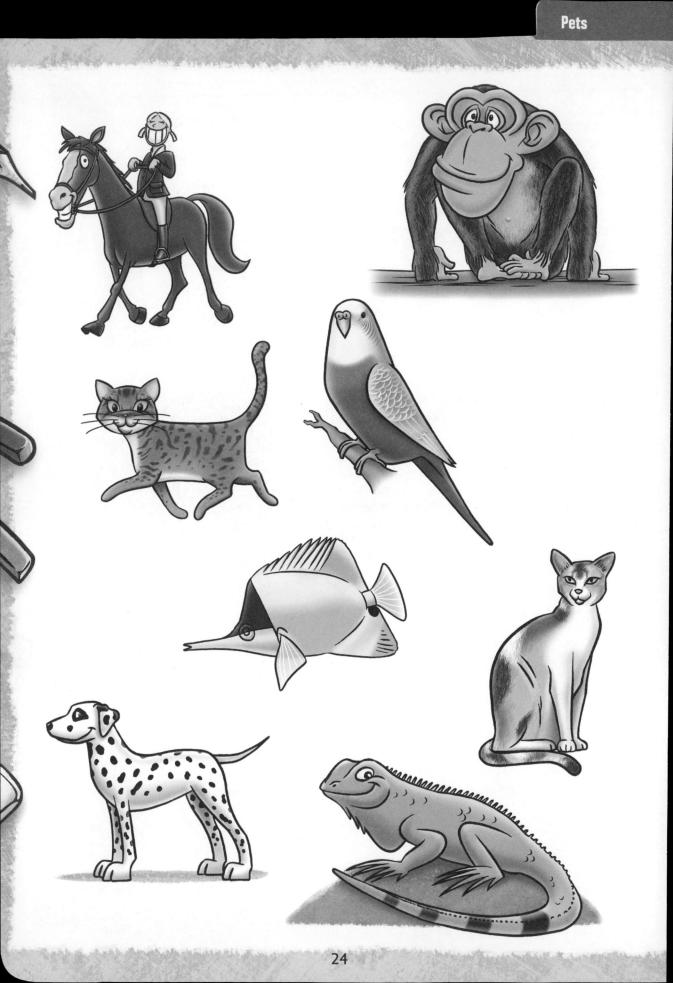

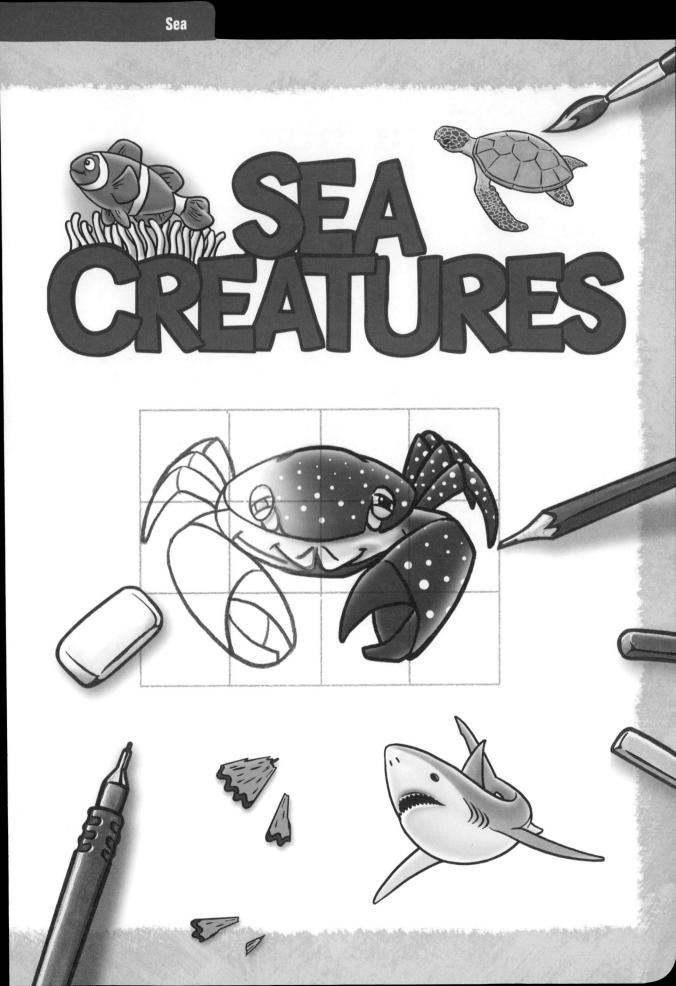

The Turtle 32

The Shark

Sharks are fish. There are over 300 varieties of shark. Some are only a few inches long and some grow to be over twenty feet long. The smaller sharks eat plankton while the bigger sharks eat fish, squid, octopuses and seals. Sharks do not have bones, but a skeleton made out of cartilage.

Ί.

Draw a grid with four equal squares going across and three down.

Draw a pointed egg in the left half of the grid. Notice the angle this egg shape is on.

2

Add a large fin toward the bottom of the egg shape reaching down to the lower left corner of the grid.

Draw a hook that flows off the rear of the egg shape. This will be the shark's lower body.

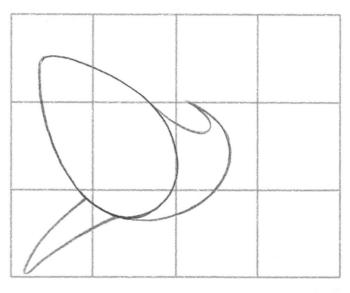

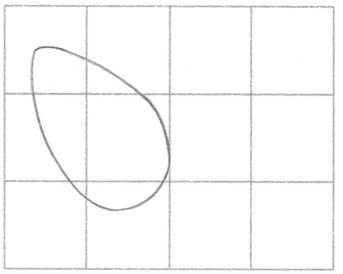

Add the dorsal fin on top of the shark. Be careful to put it in the correct place on the grid. Draw in the four gills near the rear of the egg shape.

Draw the other fin, which goes almost all the way to the right edge of the grid. Add the rear fin behind the right fin.

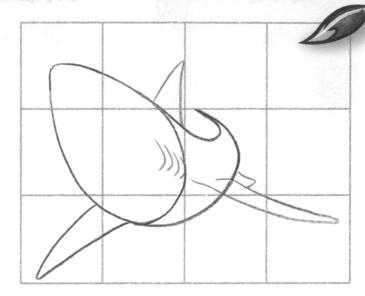

4.

Draw a curved line from the nose to the top of the first gill. Then draw a small line from the bottom of the last gill to the right fin, and from the right fin around the body. This will separate the colors.

Draw two spots for the nose. Draw in the eye. Put in a shape like an upside down moon for the mouth and add teeth to the top and bottom.

Draw the tall tail and bottom section behind the dorsal fin.

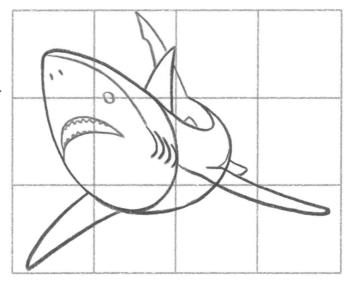

5. Outline your shark and erase the pencil. You can color your shark gray, dark green or blue.

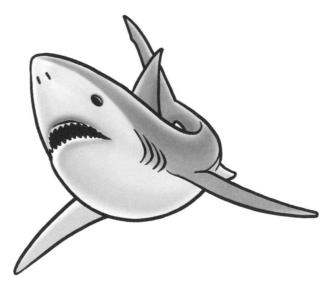

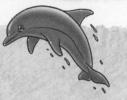

The Dolphin

The dolphin is a member of the whale family. They are warm-blooded and breathe air from the surface. Out of the 30 species of dolphins, the Bottlenose Dolphin is the most common. They live and travel in big groups called pods. Dolphins love to play and will often jump out of the water and perform various flips.

1

Draw a grid with four equal squares going across and three down.

Draw in the shape for the body of the dolphin. Even though this shape is long, notice how it is stubby at the front and more stretched out at the back.

2

Add the beak at the bottom of the body shape.

Draw a dorsal fin above the right hand side of the center of the body shape. Add the tail to finish this stage.

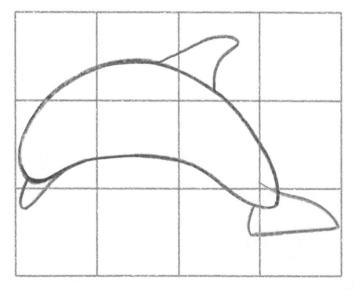

Split the beak shape in half with a line for the mouth. Draw in the eye and cheek top. Add the pectoral fins.

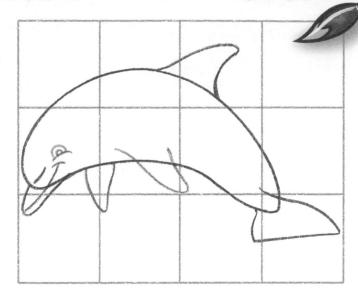

4.

Draw a line along and below the center of the dolphin's body. Add some water droplets to show that it is leaping out of the water.

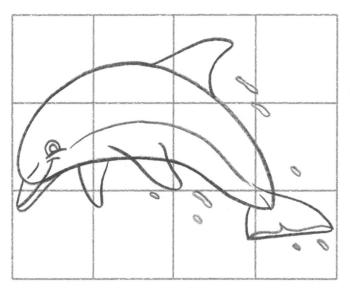

5

Outline your drawing and erase the pencil lines. I have made this dolphin gray and added highlight points around it to make it look shiny.

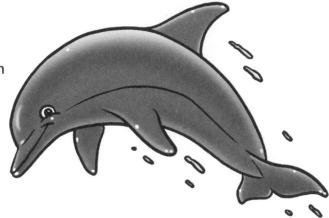

The Turtle

Turtles are cold-blooded and live in the warmer parts of the world's oceans. Turtles do not have feet but have flippers for swimming. Most of a turtle's life is spent in the ocean. They do come to land to lay eggs. On the beach, the female will dig a hole and lay many eggs. When the babies hatch, they make their way straight back to the ocean.

Draw a grid with four equal squares going across and three down.

Draw a circle for the head in the top left square of the grid. Draw in the shape for the shell.

Notice the wire-frame line between the head and the shell. If this line was carried through the head and shell, it would show that the whole drawing is based in this direction.

Draw the beak on the head circle. Join the head to the shell at the top. Draw in the neck and large flipper on the underside.

Add the back flippers. Notice the flipper on top is slightly smaller than the one on the bottom.

Draw in the shape for the eye.

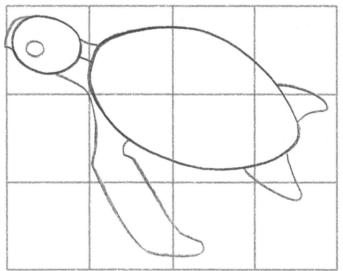

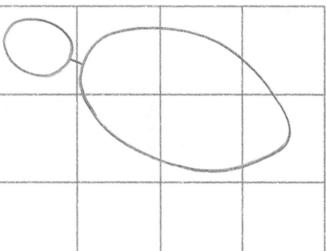

Look closely on the grid to see where the shell pattern falls. The hexagonal shapes are not in the middle of the shell, but are more toward the top side. This makes the shell look three dimensional.

Draw in the leaf-shaped eye to finish this stage.

Outline your turtle and color. The

with a little blue lightly mixed in,

in patches.

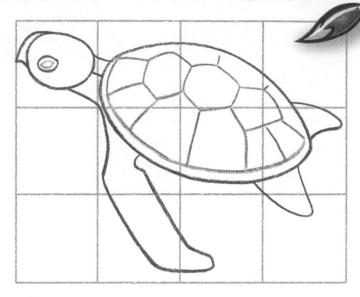

Artist Tip:

The head and flippers have many shapes on them. If we drew them all in with our outline marker, it would darken the picture too much. This is because things in life are rarely colored black. See how dark the drawing to the right is with too many detailed shapes done with an outline marker. When using your marker, try to limit the detail of your subject.

Notice how some of the outlines for the pattern on the turtle's shell do not go right to the edge or meet up with each other. This is another way of limiting detail.

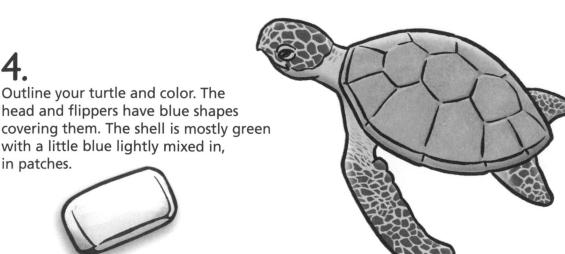

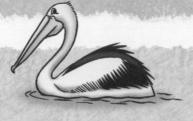

Pelican

Pelicans are big majestic birds. Their wingspan can reach over six feet in length. They also have a very long beak that they use to scoop up fish out of the water to eat. They float very well and have webbed feet for paddling. Pelicans are found in warm parts of the world. They nest in trees and sometimes on the ground.

1. Draw a grid with four equal squares going across and three down.

Study the shape for the body. It has a long slope going up and a shorter steeper slope going down. Draw this in on the correct place on your grid.

2

Draw the shape for the wing inside the body shape.

Draw a shape for the head near the top of the grid. Draw two curved lines for the neck, merging it into the body.

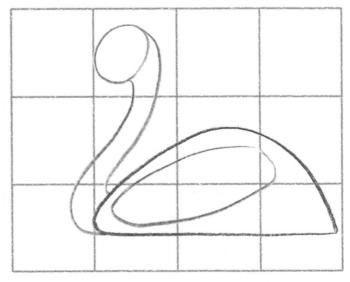

Add the beak onto the head shape. Draw in the eye and whiskers on the back of the head.

Draw a zig-zag line and some straight lines for the feathers on the bottom of the wing shape.

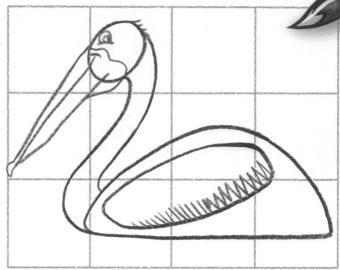

4.

Draw the jagged lines on its back for the rough feathers. Add some more jagged lines going across from the wing to the rear of the body.

Put in some water ripples to finish this stage.

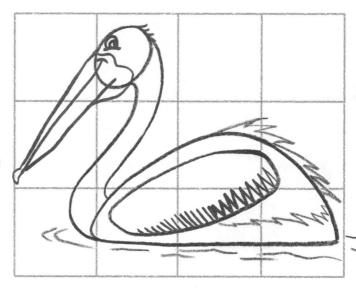

5.

Outline your pelican and erase the pencil lines. Most pelicans are black and white. I have used a gray pencil to shade some of the white areas.

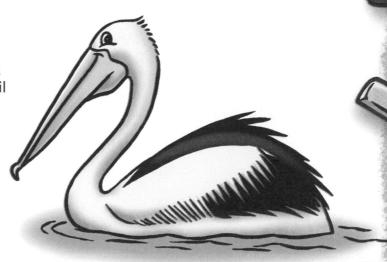

Clown Fish

There are many different types of clown fish. This is the Percula Clown Fish, which is the most well known. They live in tropical areas of the world where the water is warm. The clown fish's friend is the anemone. It has long tentacles that the clown fish hides in. These tentacles kill and eat other fish but the clown fish has built up an immunity to its sting.

1.

Draw a grid with four equal squares going across and three down.

Draw in an oval shape that is pointier at the rear. Make sure the oval is slanted in an upward direction.

2

Add on the dorsal fins on top of the body shape. Notice how they start in the second square from the left of the grid. Draw on the surrounding fins and add the tail.

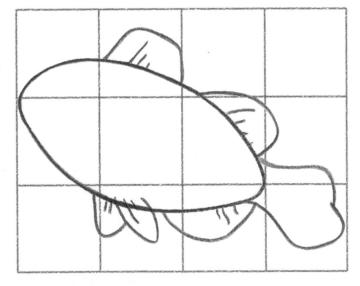

Draw a mouth that looks like a stretched "S" on its side. Draw in the eye and add a curved line above it for the brow.

Add the pectoral fin in the middle of the body. Note the large size of the pectoral fin.

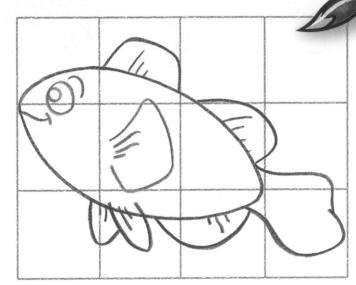

4.

Add three stripes. These surround the head, fall behind the dorsal fins and circle the tail.

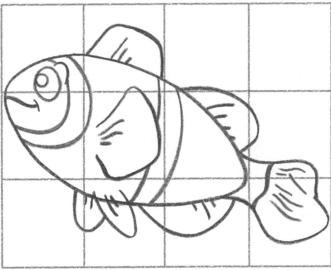

5.

Outline your artwork and erase the pencil lines. Color your clown fish.

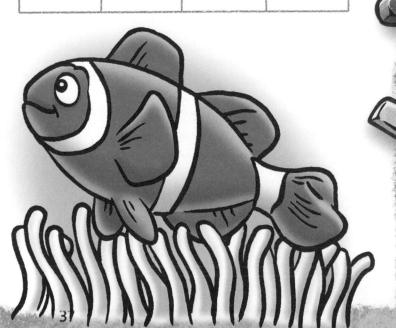

The Crab

Crabs are ten-legged crustaceans that walk sideways. They have two large claws called pincers that they use for feeding or to defend themselves if necessary. All their bones are on the outside. This is called an exoskeleton. There are more than 5000 species of crabs. Some live in the ocean and some live on land.

I. Draw a grid with four equal squares

going across and three down.

First, draw in an oval for the crab's body. Draw in two more shapes pointing down and towards the center of the grid. These will be the pincers.

2.

Add a shape that is wide at the top and comes to a point for the legs on either side of the body shape.

Join the pincer shapes to the body at their tops, below the leg shape we have just drawn. Draw a curved line on both of the pincers.

Draw a curved line through and just under the middle of the oval for the body.

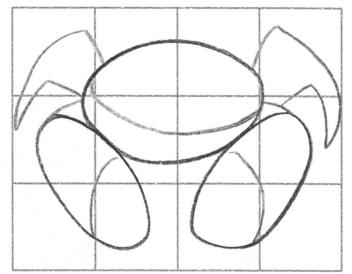

bellenden de

Sea

Sea

3.

Break the legs shapes up into three legs using two lines on each.

Add the eyes above the middle line in the oval body shape. Draw the mouth parts under this line.

Define the pincers.

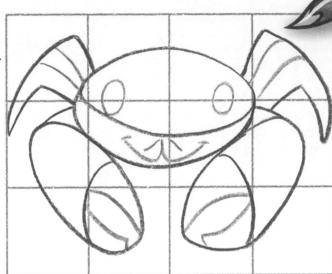

4.

Put joints in on the legs. Draw a small hump at the top of the oval for the body shape. Draw in the parts underneath the eye.

Draw in a line to make the bottom of the shell and pincer arms.

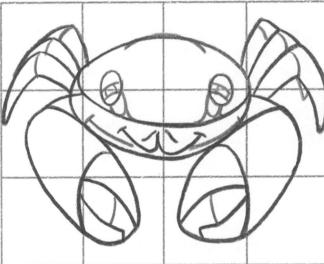

S

5. Outline your crab with your marker and erase the pencil lines. Color your crab.

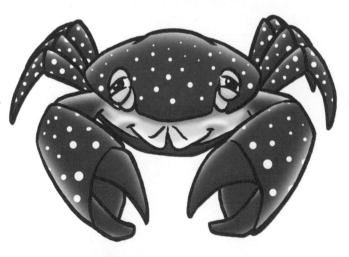

The Penguin

Penguins are birds. They cannot fly through the air but they do "fly" through the water with their flippers. Penguins hatch from eggs like other birds. They are only found below the equator and like to swim in icy cold seas.

1

Draw a grid with two equal squares going across and four down.

Draw the head shape in the correct position on the grid. Draw the body shape and move on to stage two.

2.

Draw the beak on the front of the head shape. Draw in the eye and the mouth.

Draw in the neck, which flows onto the head and body shapes. Draw the puffy legs at the bottom of the body shape.

Sea

Draw in the flippers (or wings) around the middle of the belly.

Draw a line from the neck to the flipper. Then continue it down to the back of the leg. Draw in the feet and a little bit for the tail.

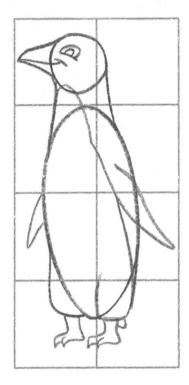

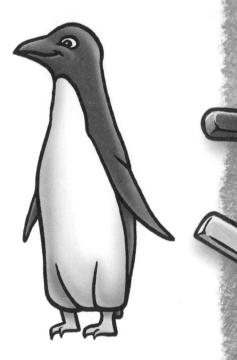

The Marlin

The marlin is a big, fast-swimming fish that lives offshore in deep waters. Marlin eat tuna, which are also very fast swimmers. The marlin has a long bill that it uses to stun the fish once it has caught them. It then turns around and eats them. It will also eat squid and large crustaceans. Marlin grow to be over four meters long and weigh nearly a ton.

Draw a grid with four equal squares going across and three down.

Begin with a shape that looks like a bent teardrop. Make sure this is positioned correctly on the grid as the bill is long and takes up a lot of room.

2

Draw the bill so that it merges with the front of the teardrop and almost reaches the bottom left corner of the grid.

Draw the flipper that reaches to the right hand edge of the grid. Add a curved tail end from the point of the teardrop.

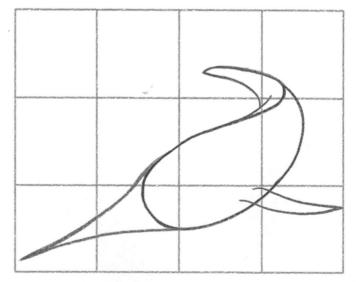

Draw the mouth inside the shape for the bill. Add gill lines behind the mouth.

Draw the dorsal fin near the top of the teardrop, reaching along it to the point. Draw the tail fins on the curved tail section.

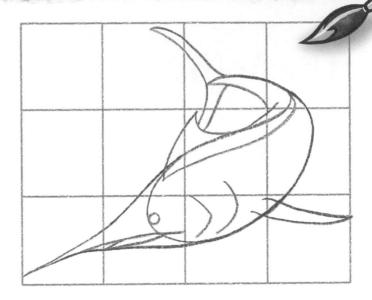

4. Draw a thick line that stretches from the bill right through to just below the point of the teardrop. Draw in the fin on the other side of the body and the fins near the tail.

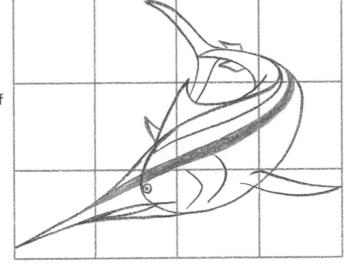

5.

Outline your marlin and erase the pencil lines. Marlin range from green to blue in their coloration. Their sides and undersides range from white to silver. They have gray colored stripes that run vertically along the body.

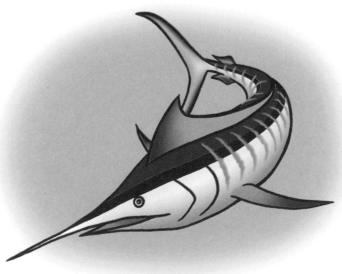

The Whale

This is a sperm whale. The sperm whale is very large and has a distinctive shape. Its nose is flat, not pointed like most whales. It is the largest whale to have teeth and uses these to eat giant squid. Diving very deep in the ocean where it is completely dark, the whale uses sonar to locate its prey. The sperm whale can stay underwater for up to an hour before it needs to breathe again.

1.

Draw a grid with four equal squares going across and two down.

Start with what looks like a stretched jelly bean at the left hand side of the grid. Check that your shape looks just like this one before moving on to the next stage.

2.

Add the bottom jaw below the shape. Notice it starts from around the middle of the first shape. Draw in the eye slightly to the right and above it.

Draw in the fin and a hook shape for the lower end of its body. Draw in the bottom of a semi-circle capped with a line for the tail.

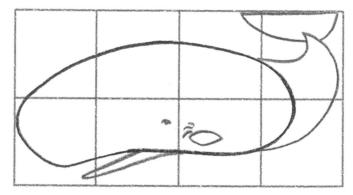

5. Draw dorsal fins on the hook of the body. There are three fin lumps on this whale. Define the tail in the capped semi-circle.

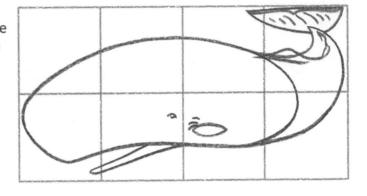

Artist Tip:

Adding a few different-sized bubbles here and there is a great way of making things look like they are under water. A wavy line with a few dots can make up the sand. Some seaweed and a couple of rocks can finish off the ocean floor. Keep background lines very simple. That way the object of the picture, the whale, stands out.

4. The sperm whale is a whitish gray color. In the water it can appear blue.

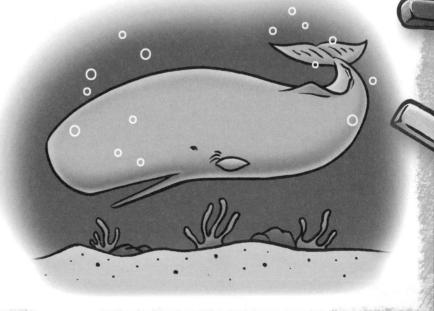

Sea

The Walrus

Large and strong, the walrus powers its way through the sea. It dives deep to the ocean floor in search of clams, snails, worms and crustaceans to eat. It surfaces and makes its way onto land where it sunbakes with friends. The walrus has two very long tusks, which it uses to drag itself along with on land and to defend itself against predators.

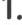

Draw a grid with three equal squares going across and down.

Draw a circle right of the middle of the grid for the head. Draw the body shape which begins at the left side of the head circle. Check to make sure your shape is the same as this one.

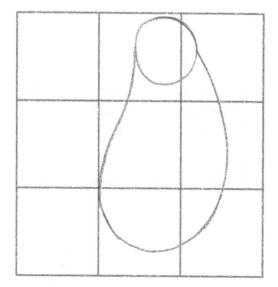

2

Draw a circle slightly to the left and a little lower than the first head circle, but about the same size. This will be the snout.

Draw the lower body shape, making sure to merge it onto the original body shape.

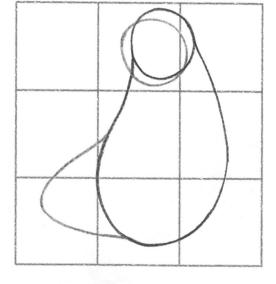

Draw in the nose, which looks like a sideways "B", slightly to the left of the middle in the top of the snout circle.

Divide the cheeks in the snout circle with a line and draw in the long tusks. Draw in the front legs and fins. Add the back fin to finish this stage.

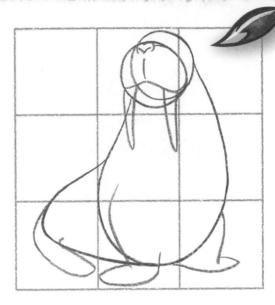

Draw the eye and eyebrow on the top right of the head circle. Add whisker spots to the cheeks and a line to define the chin.

Separate the fins with some lines and add the crease on the back.

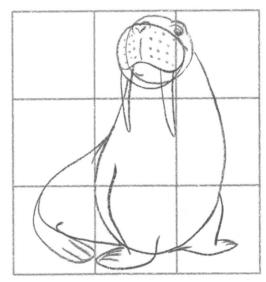

5.

Once you have outlined the picture and erased the pencil, put in a few selective whiskers coming from the whisker spots. Do not put too many in as it will darken the drawing too much.

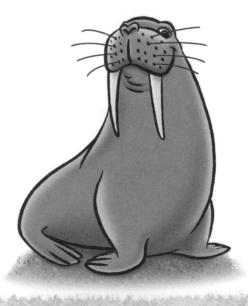

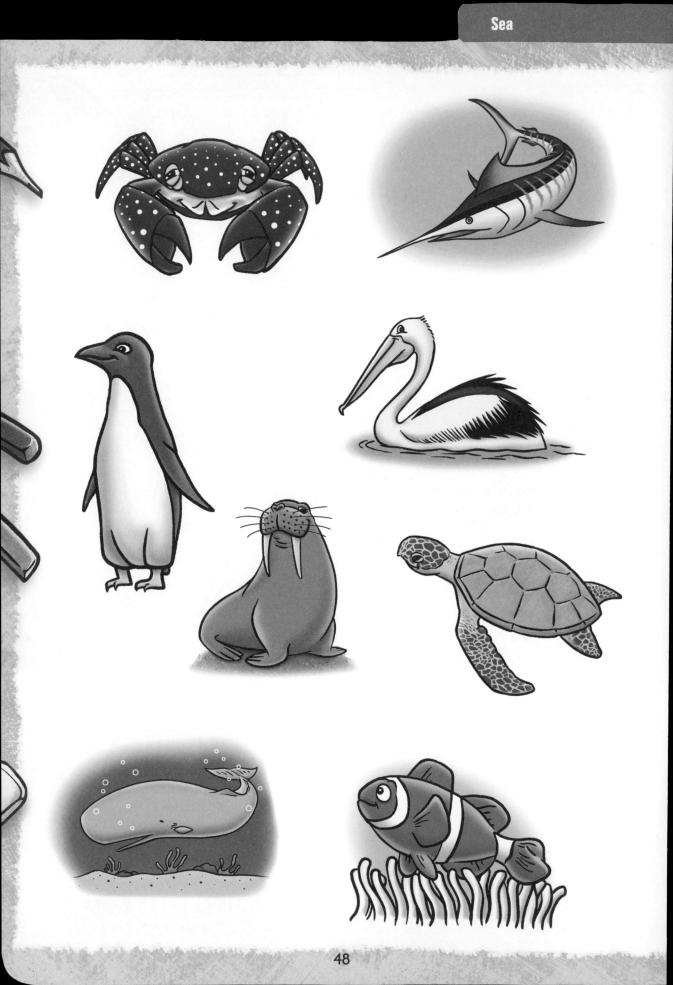

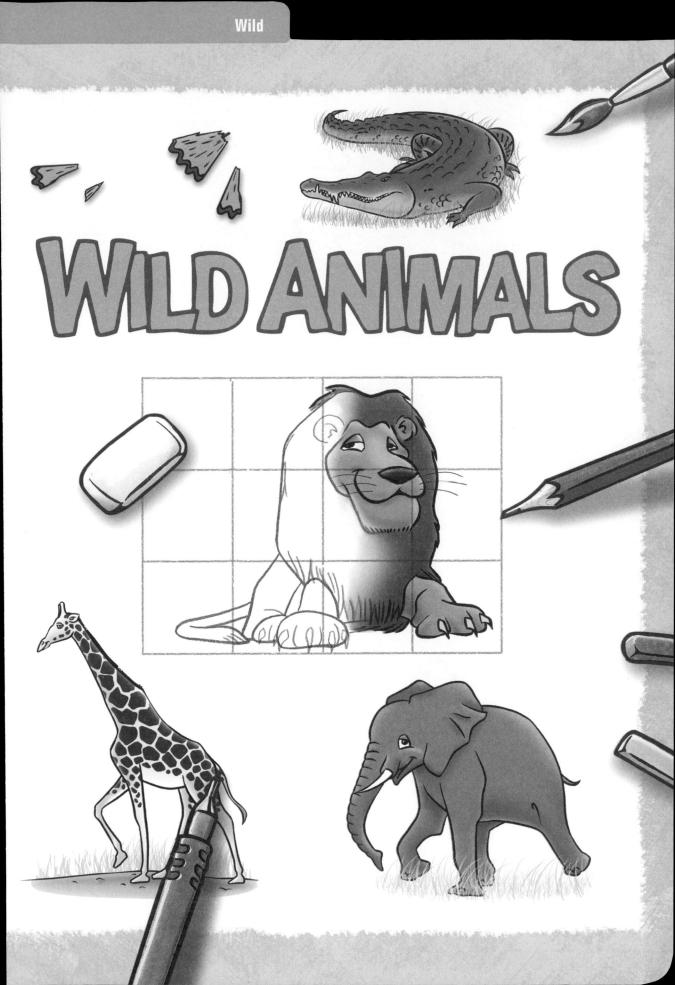

Contents

..... 54

The Elephant 52

The Lion

Hippopotamus 56

Rhinoceros 58

The Leopard60

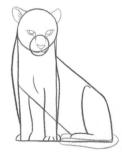

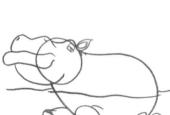

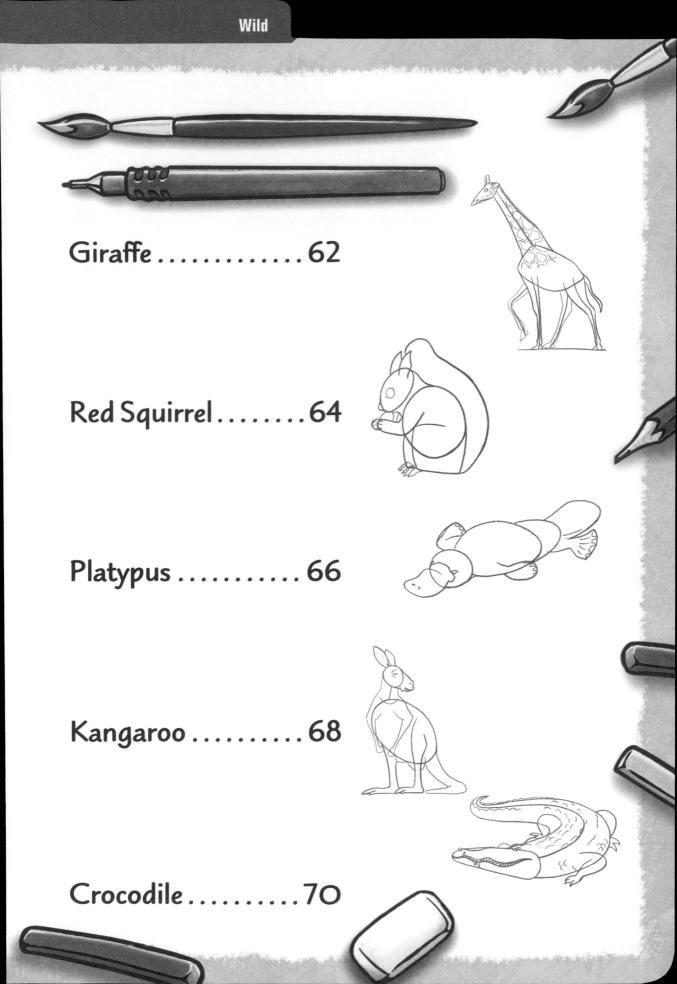

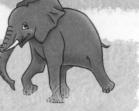

The Elephant

The elephant is the largest land mammal in the world. This huge animal can weigh more than four and a half tons and can spend up to 20 hours a day eating grass, leaves and bark. Elephants live in groups called herds. An elephant's life span can be as long as 80 years.

1

Draw a grid with four equal squares going across and three down.

Draw the oval for the body first. Next draw the circle for the head. Notice how the front wire-frame leg is at the end of the body shape. The middle wire-frame is nearly half way along the body shape. The last wire-frame leg is at the other end of the body shape.

Draw in a ground line and check everything is in the right position.

2.

Draw in the tusk near the bottom left of the head circle. Add on the legs based on the wire-frames. Notice how the middle leg extends right up into the body.

The back leg flows smoothly onto the body shape so there is no way to tell where it joins.

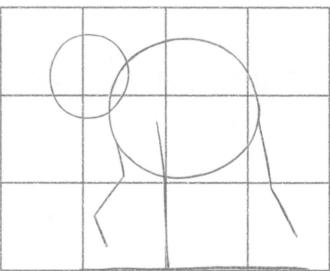

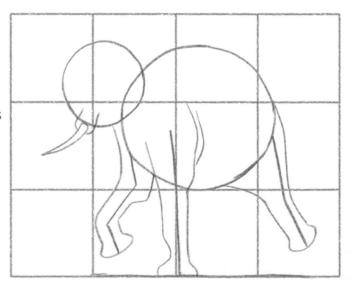

3

The trunk flows off the head at the front in the same way the back leg flowed off the body shape in the previous stage.

The mouth starts under the tusk and extends outside the head circle. Above the mouth is the cheek and eye.

Add in the other back leg, which is situated behind the middle leg. Draw in the crease in the back leg and add on the tail.

4.

Draw on the curved ridges of the trunk. Add the eyeball and the ears.

Imagine where the front of the elephant's foot is on each leg and add some toenails.

When you are ready to outline your artwork remember to only draw in the lines needed to make the picture. Check the final picture to see which ones you need.

5

Once you have erased the pencil lines, color your elephant and add some dry grass.

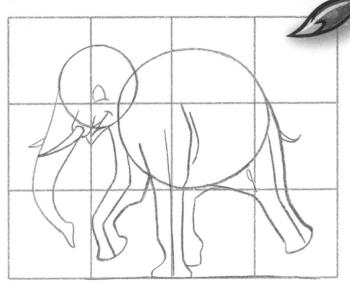

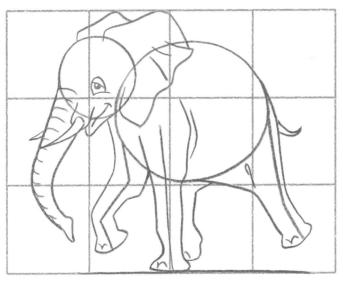

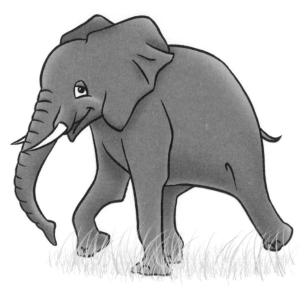

Wild

The Lion

Lions live and hunt in groups called prides. Great eyesight and a keen sense of smell helps the lion catch its prey. When chasing, they can reach speeds of up to 50 miles per hour. Resting is also important. A lion can sleep for up to 20 hours a day. A lion's roar can be heard nearly three miles away. Only male lions have a mane.

Draw a grid with four equal squares going across and three down.

Start by drawing a shape for the snout. Add a similar shape for the head behind it. Check to see if your drawing is correctly positioned on the grid.

2

Draw in another shape around the first two shapes. This will be the mane around the neck.

Add shapes for the feet and the legs coming out of the mane.

Wild

3.

Draw in the shapes for the back leg, foot and tail.

Draw in the nose on the right side of the snout shape. Modify the mane that was drawn in the last stage.

Draw in some lines and points to make the mane look scruffy.

Put the ears on just outside of the head shape. Draw the eyes pushed up by the cheeks. Divide the mouth parts into a curved "W" and define the bottom jaw.

Finally, divide the foot into paws and add sharp nails.

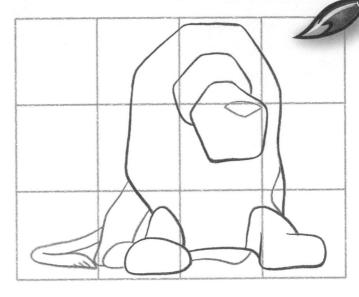

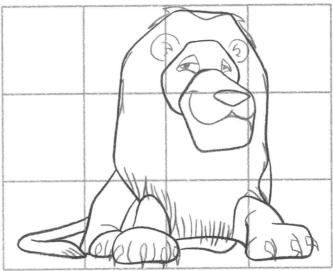

5. Outline your lion with a felt-tip marker and erase the pencil lines. You are now ready to color. Keep the body a tan color while making the mane a darker, more reddish color.

Hippopotamus

The hippopotamus is a huge animal that can grow to be over twelve feet long and weigh nearly two tons. Its head alone can weigh a ton. It eats up to 100 pounds of leaves per night and during the day retreats to the cool of the river where it can drink up to 65 gallons of water. Hippos are only found in Africa where they live in herds.

1

Draw a grid with four equal squares going across and three down.

Draw in the head circle first. Add the body shape. Make sure the body shape is correct before going to the next stage.

2

Draw in a wavy line for a water line. The water line in front of the hippo should be a little lower than the rest of the water line.

Note where the legs are in relation to the grid and draw them in. Because the legs are so short there is no need for wire-frames here.

Wild

3. Draw the mouth and define the eye on the head circle.

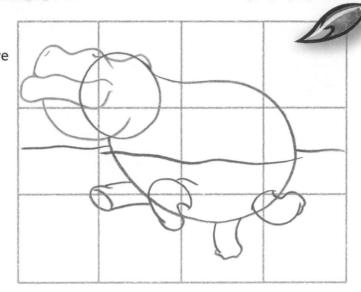

4. Add on the eye and ear and the creases on the back of the neck, and you are ready to outline your hippo.

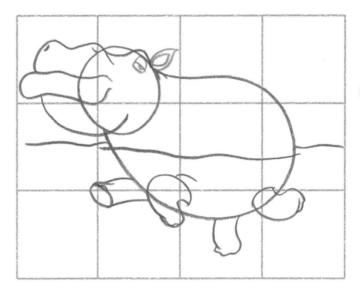

5. Color your hippo and the water. Notice how the hippo is darker below the water line.

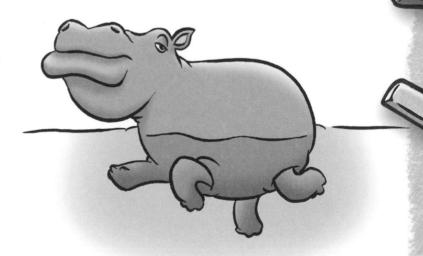

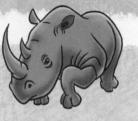

Rhinoceros

Rhinos are large animals found in both Africa and Asia. They can grow to be nearly six feet tall, twelve feet long and weigh almost two and a half tons. Being herbivores, they only eat grass and leaves and sometimes plants with sharp thistles. Rhinos have excellent hearing but cannot see things close to them very well.

1.

Draw a grid with four equal squares going across and three down.

Start with an oval for the head. This oval is on a slight angle. Draw in two larger and wider shapes behind the first oval. Notice these shapes are pointier than a normal oval. They are more like an egg on top.

Check that your shapes are correct and in the right places on the grid.

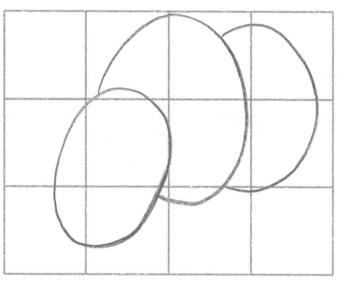

2

Use the grid to position the horns on the head circle. Draw in the lip outside the head circle.

The eye is slightly below the center of one of the grid squares. Draw a leaf shape for the ear in the top half of the grid square.

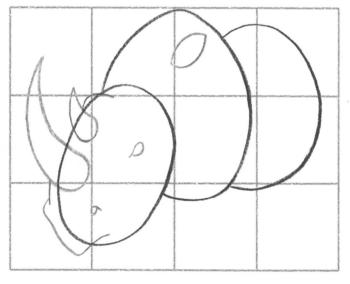

3

Draw in the other ear opposite the first ear. Continue the head above the first head circle. Add some crease lines around the first ear and around the eye.

Draw in the legs and rounded shapes for the feet.

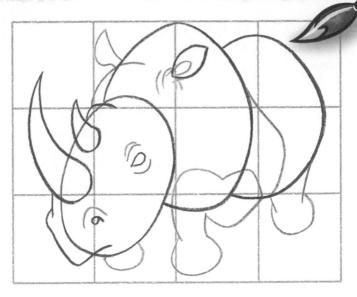

4. Draw creases in the shoulder above the front leg. Draw a curved line between the front and back leg to define the stomach.

Break the feet up into toes. Notice how the back toes are smaller than the front ones.

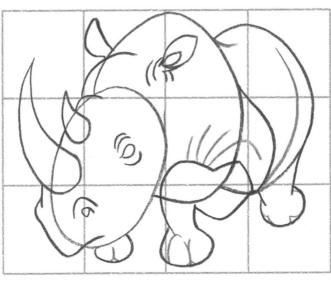

5.

Outline your rhino and erase the pencil lines. Rhinos can be different colors, from white to gray to brown. You could put a shadow a centimeter below the rhino's feet to show it is in the air running.

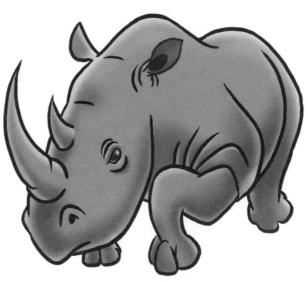

The Leopard

Leopards are very strong and fast members of the cat family. They can drag freshly caught animals that are much heavier than themselves up a tree to keep it away from lions and hyenas. They are amazing jumpers, able to leap 18 feet forward in a single bound and ten feet straight up. Each leopard has its own unique spot pattern.

1.

Draw a grid with three equal squares going across and three down.

First, draw in the head in the top left of the grid. Draw in the tall rectangle on its side under the head circle. Draw in the last shape on the right side to complete this stage.

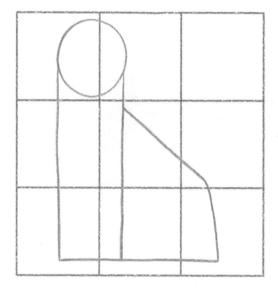

2

Draw a small circle on the bottom of the head circle just going outside of the head circle.

Draw in the legs around and inside the long rectangle. Draw in the underside of the belly line and add the shapes for the back leg and the foot.

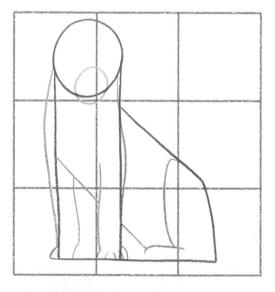

3

Add the ears to the outside of the head circle. Draw in the facial features, being careful to put them in the correct place on the circles.

Draw in a line to divide the chest. Add the tail and back foot to finish.

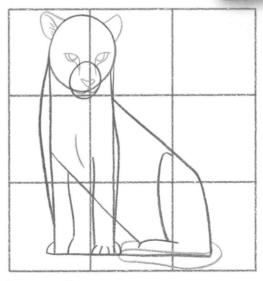

Artist Tip:

The leopard's mouth, chest and stomach are all white. Notice though there is no edge to where the white starts and the coat color finishes. It is a gradual color fade. When coloring with pencil, push harder at the edge of the picture and gradually lighten pressure as you move toward the center of the drawing. You may need to do this a number of times to build up the coat color.

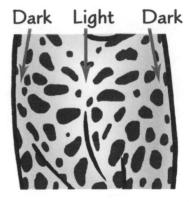

Add spots to the head and chest, making them smaller as they fade out. The spots on the back have holes in them where the color of the coat is slightly darker than the rest of the yellow coat.

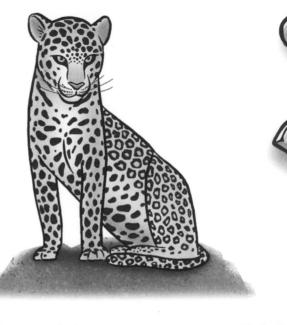

Giraffe

At 15 feet tall, the giraffe is the tallest animal in the world. It eats leaves and can consume 130 pounds of leaves in one day. The giraffe's heart is as big as a basketball and, if challenged, it can kill a lion using its bony head.

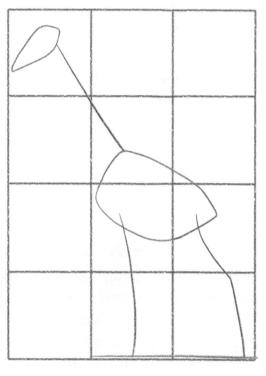

1.

Draw a grid with three equal squares going across and four down.

First, draw in the shape for the body on the grid. Draw the pointed head shape and connect it to the body with a wire-frame.

Add in the curved and kinked wire-frames for the legs. Lastly, draw in a ground line.

2.

Draw in the horn on the head and the facial features. Add the neck, being sure to make it slightly wider as it goes down toward the body.

Draw in the legs around the wire-frame guides and add the new wire-frames for the legs behind. Add on the tail.

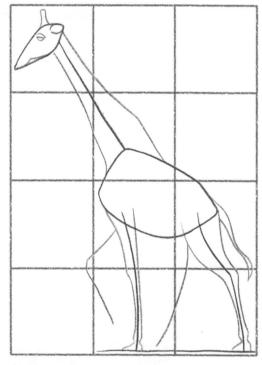

Add the other horn on the head, and the far legs. Draw the mane on the back of the neck. Giraffes' manes are quite short so don't make it too thick.

Finally, add in the shapes for the pattern on the coat. Notice how they get smaller and fade out on the face and legs.

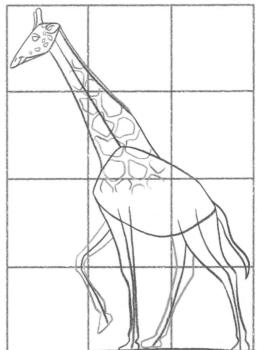

Add spots all over the legs, back and head. Be careful not to put spots too far into the chest or on the snout. Color your picture.

Red Squirrel

The Red Squirrel lives in trees. It can be found in the United States, Canada and England. They are excellent climbers and can leap from branch to branch around the forest canopy. Squirrels are wary creatures. Great eyesight, sense of smell and hearing all help to protect the squirrel from predators. A squirrel can fall from great heights out of a tree and live.

1.

Draw a grid with three equal squares going across and down.

Start by drawing in a circle for the body shape a little lower than the middle of the grid.

Draw in the head shape, which looks like an egg facing toward the ground on an angle.

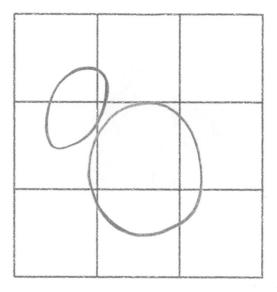

2

Connect the head shape to the body shape with a curved line.

Draw on the arms. Notice how the arms flow off the edge of the circle at the top.

The squarish shape for the back legs also flows off the body at the back. Check your drawing is correct and move on to the next stage.

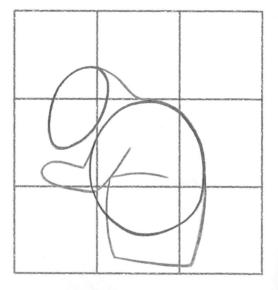

3

Here we have drawn in the ears. They are curved to a point at the top. Draw on a little shape for the nose and add the other paw beside the first arm.

Draw in the other leg at the front. Draw in the long, thick tail that curves around the body and extends above the head and ears.

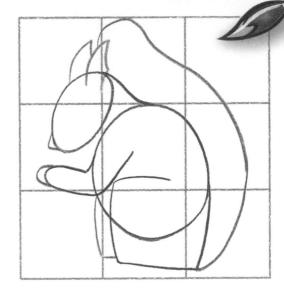

T. Draw in an oval shape for the nut in its paws. Draw in a curved line that goes from the top of the nut to the body circle for its neck. Add in the other arm below the neck.

Draw the claws on the feet at the base of the square shapes for the legs.

5. Outline your squirrel and erase the pencil lines. Color it with red while using brown

for the shaded areas.

S P

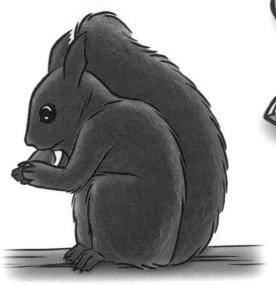

Platypus

Platypus are only found on the east coast of Australia. They are about half the size of a house cat. They have a bill like a duck and a tail like a beaver. They use their bill to forage for food along the bottoms of rivers. They eat fish, fish eggs, frogs and tadpoles. A platypus is able to hold its breath for ten minutes under water. At night they sleep in burrows in the river bank.

1.

Draw a grid with four equal squares going across and two down.

Begin with a circle in the bottom left of the grid. Add a shape for the body. Notice how the body shape is slightly rounder on top than on its underside. Check that you have drawn the body shape correctly and move on to stage two.

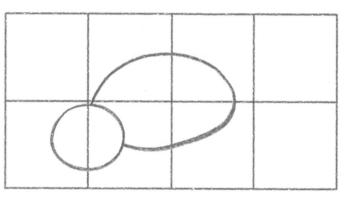

2.

Here we add the bill. It is very wide and fairly flat.

Add another shape on to the body shape at the rear.

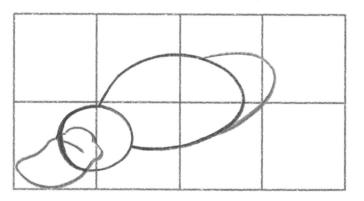

Wild

Wild

D. Draw on the arms and legs. When drawing the tail, notice how it is quite straight and broad.

Make sure everything is in the correct position and move on to the next stage.

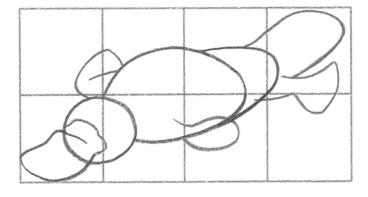

4.

Here we can finish with the detail. Put a couple of short lines on the end of the bill for the nostrils. Draw the eyes touching the bill.

Connect the head circle to the body circle. Break up the shapes on the end of the arms and legs into claws.

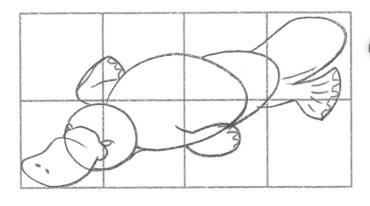

67

5

Outline your platypus with a felt-tip marker and color it. The platypus here is swimming, so you may like to put some water around it.

Kangaroo

Kangaroos live in Australia. They have strong, muscular legs and a thick, heavy tail. A kangaroo can only move its back legs together and uses its tail as a third leg when moving slowly. Kangaroos have good eyesight and excellent hearing.

1

Draw a grid with three equal squares going across and four down.

First, draw in the body shape on your grid. Draw the head next and connect it to the body shape with a wire-frame. Check to see whether your shapes are positioned correctly on your grid.

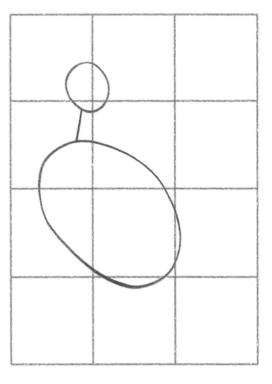

2

Draw leaf-shaped ears on the head circle. Notice how the ear on the right is slightly smaller because it is further away.

Add the snout and mouth. Draw in the legs and the feet.

The facial features are next with the eye, nostril and dividing line for the cheeks.

Next, draw in the neck and arms. Draw in the underside and the tail to complete this stage.

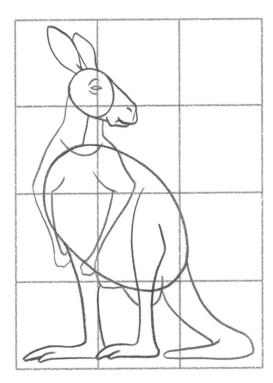

4. This is an eastern gray kangaroo, so we have colored it a bluish gray.

Crocodile

Crocodiles are large reptiles. They live on both land and water. On land they can move at speeds of 50 miles per hour in short bursts. Under the water they can hold their breath for five hours. They can also go months without eating. Crocodiles are cold-blooded, which means they have to lie in the sun to warm themselves up.

1.

Draw a grid with four equal squares going across and two down.

Start with a shape that looks like a stretched egg in the bottom left hand corner of the grid.

Draw in the "S" shaped line. This line is a guide that runs through about the middle of the animal. By having this guide, the body and tail can run in line with it.

2.

Build the body shape along the line, bringing it to a point at the end of the line. Notice how the body widens and then tapers off to a point at the end of the tail.

Wild

Add the shapes for the legs, being careful to place them in the correct positions on the grid.

Draw in two wavy lines for the crocodile's mouth.

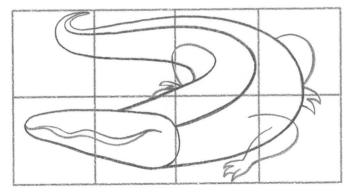

Put in some large, spikey teeth and then add in the rest of the teeth with a simple zig-zag pattern.

Redefine the snout and add the eyes and edges above the eyes.

Draw in some scales running along the top of the back and then some on the side of the body.

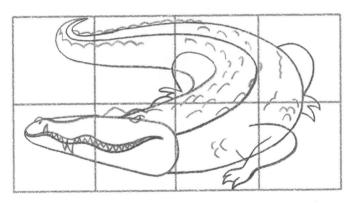

5. Crocodiles are light colored on

their belly and generally a darker green on top.

You may like to draw a river scene in the background. You could draw a set of eyes poking out of the river as if another crocodile is lurking nearby.

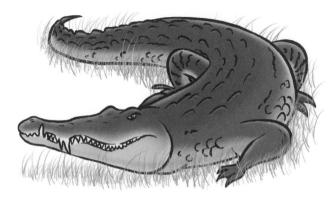

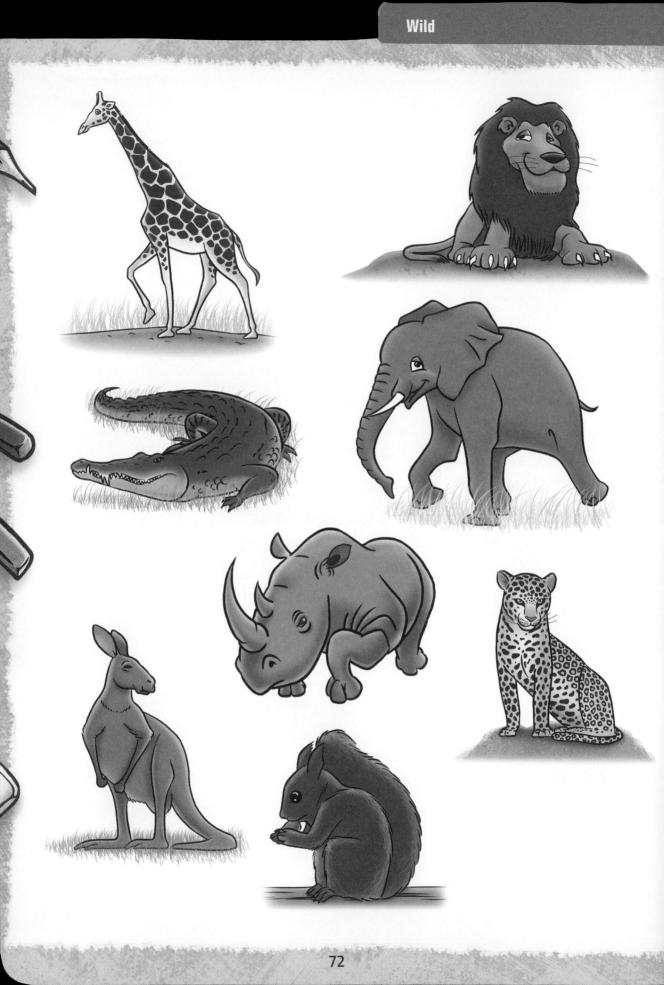

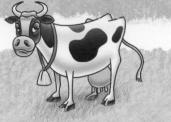

The Cow

Cows are females. They are big creatures that spend most of the day eating grass. That's a lot of grass, so they have four stomachs to put it all in. When they are not eating they are generally resting. There are many types of cows. Some cows are bred to produce milk to make dairy products and some cows are bred for meat.

1.

Draw a grid with four equal squares going across and three down.

Look to see where the shapes are located on the grid. Draw your head and body shapes in the same positions and draw a small line between the head and body.

Check you have drawn the correct shape and it is in the right position on the grid before going on to the next stage.

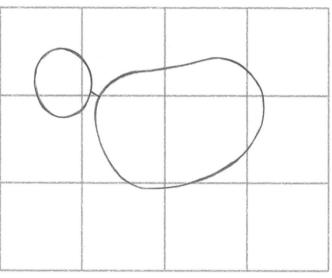

2.

Here we add more simple shapes for the horns, snout and udder. The legs are drawn in as wire-frames at first. This shows us where to draw around them to fill them in later.

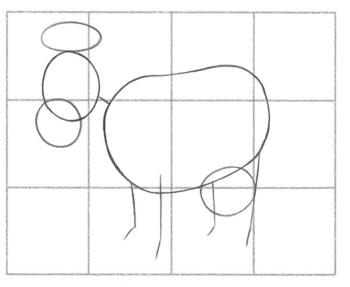

3

Once the basic shapes have been put in, details can be added. Here the eyes, nose and mouth have been drawn inside the existing head and nose shapes. The ears, horns, neck, tail and hips are drawn onto the basic shapes. Notice how the legs and feet are drawn directly over the top of the wire-frame legs.

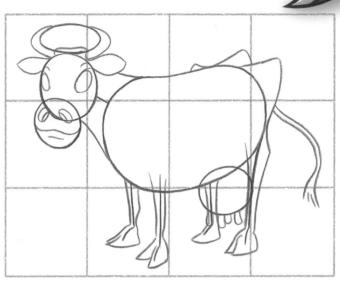

Artist Tip:

Notice the lighting and shading on the body. Light wraps around the objects. The snout, face, body _{Li} and udder all have light on their undersides.

Just above that light is some shading. Anywhere light does not hit will be shaded. The inside of the leg is a good example of this.

4

This is a lazy dairy cow. Lowering the eye-lids over her eyes gives her a lazy expression.

Add some grass and maybe even a mountain range in the background to finish the scene.

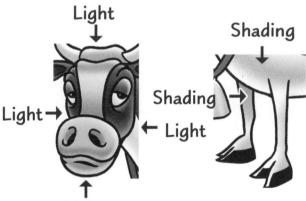

Light

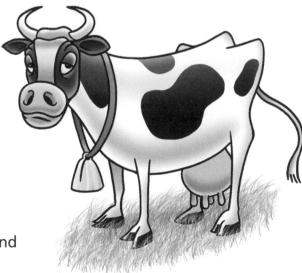

The Dog

Dogs are known as "man's best friend". These intelligent animals can be trained to perform many tasks. On cattle and sheep farms they round up livestock and can herd them from one paddock to another. The farmer will often use a whistle to communicate to the dog where he wants it to go.

1. Draw a grid with four equal squares going across and three down.

Again we draw in the body and head first using basic shapes. As with all the basic shapes in this book, try to imagine these shapes being 3-D.

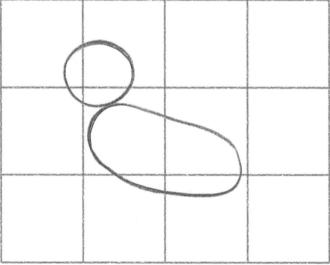

2.

Add the ears, the top of the head and the snout.

The tail and the legs are wireframes to show which direction they are pointing.

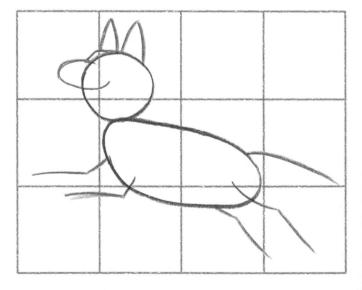

Draw in the neck and mouth. Add the eye at the top of the head shape and a nose on the snout.

Then draw the legs and tail around the wire-frames.

A.
Finish the picture with some color. Here I have put in a fence that the dog is jumping over. You may like to put in something else. You could draw in the sheep that appears later in this book.

The Sheep

Like cows, sheep spend most of their day grazing. They stay together in groups called a flock. They have poor eyesight but great hearing. Male sheep are called rams, females are called ewes and babies are called lambs. Sheep have a fluffy white coat that is called wool. Once a year they are shorn for this wool, which is then used to make clothes.

1.

Draw a grid with four equal squares going across and three down.

Draw in the shapes for the body and head in the right positions on the grid.

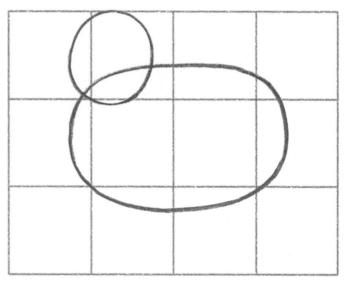

2.

Draw in the snout, mouth and some of the facial features. Add the wire-frame legs.

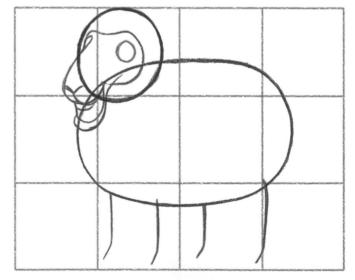

The wool is drawn around the body shape in bumps. Draw the legs over the wire-frames.

Draw eyebrows, ears and pupils in the eyes.

Artist Tip:

When using a felt-tip marker try to apply light pressure at the beginning of the line, then press down a little firmer as you go along the line. Gradually reduce the pressure when coming to the end of the line. This will give you a varied line width that can look quite effective. Notice how the lines go to points.

If using a larger marker, don't leave it in the same place on the paper. If you do this it will leave a big round ugly dot.

81

Pointed ends from releasing pressure at end of line.

4

Even though sheep are white, a light blue can be used for shading. Could this be the sheep the dog is jumping over on the previous page?

The Chicken

Chickens are very common on farms. At birth, they are bright yellow and known as chicks. In their first year they are called pullets and after that they are known as hens. Chickens cannot fly very far, although they have wings. Chickens lay eggs. If these eggs are sat on by the chickens long enough, they will hatch, revealing a baby chick.

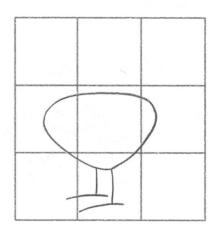

Draw a square grid with three equal squares going across and down.

Begin with a triangular shape for the body. Add wire-frame legs and feet.

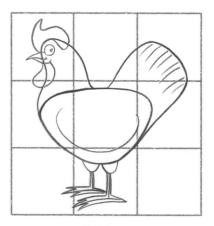

Draw in the facial features. Draw a sideways "C" for the wing and separate the tail into feathers.

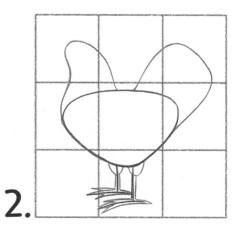

Draw the shape for the neck and head. Add the shape for the tail. Draw the legs and feet around the wire-frames, adding a couple of extra toes on the feet.

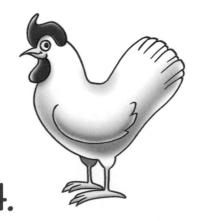

Outline your chicken, erase the pencil lines and color it in.

The Rooster

Roosters are male chickens. They are well known for their loud announcements of "cock-a-doodle-doo!" at dawn. Roosters do not get along well with other roosters and will fight to establish their dominance. For this reason there is usually only one rooster allowed in every coop of chickens.

1

Draw a grid with two equal squares going across and three down.

Draw in the body shape and the wireframe legs and feet.

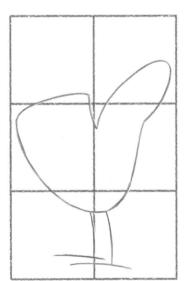

2. Add a shape for the head and the crest on top of the head. Draw on some basic shapes for the arms and add in the toes.

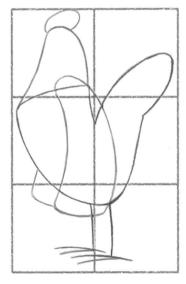

3. Facial features can now be added and the body can be defined within the basic shapes. Draw in the face, feet and hands and define the tail feathers.

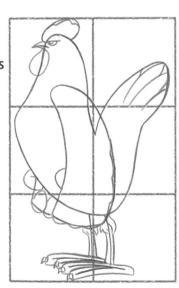

Color in the rooster to finish.

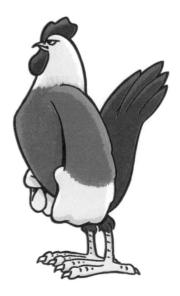

The Duck

Ducks spend most of their time on water. They have wide, flat bodies covered in waterproof feathers that enable them to float very well. Webbed feet allow them to paddle around with ease in the water. They are also well known for flying. Ducks can fly great distances to escape severe cold temperatures.

1.

Draw a square grid with three squares going across and down.

After the body and head have been drawn in, a long wire-frame neck has been added. This makes it much easier to show where the neck will be positioned.

Complete the picture following the orange shapes and lines on each stage. When the duck is outlined, erase the shapes and color.

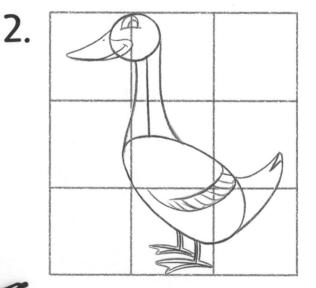

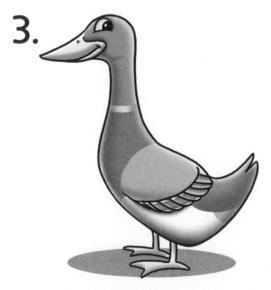

1.

Draw a square grid with three squares going across and down. Draw in the body first, then the head and wire-frame.

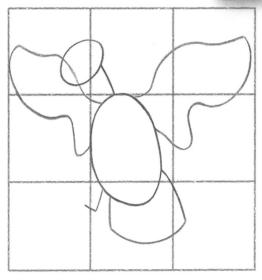

2.

Add the shapes for the wings and tail and a wire-frame leg.

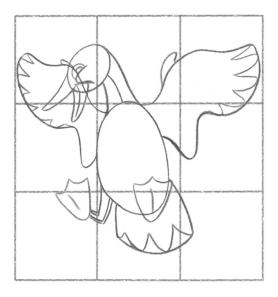

2.

Define the features in the wings and tail. Add the face and neck. Draw in the feet and the leg surrounding the wire-frame.

3.

85

Color the duck, not forgetting to add shading to the parts blocked out by the sun such as the feet and stomach.

The Bull

A bull is a male cow. They are much more muscular than cows and have thicker legs. Bulls can be aggressive and have a lot of weight to throw around if they want to. They will charge if provoked. Like cows, they spend most of their day eating grass or otherwise resting.

1. Draw a grid with four equal squares going across and three down. First draw in the basic shape for the body.

2.

Add the shape for the head and a squarish shape for the rear of the animal.

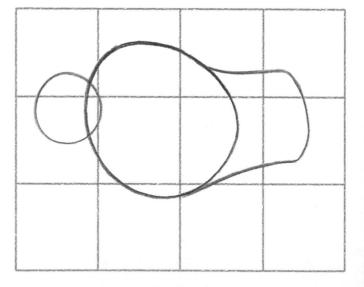

Add a circle that will become the nose and mouth. Put in wire-frames for the legs and a kinked tail.

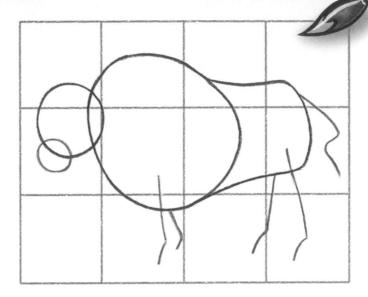

4

Draw in the face, ears and horns and connect the bottom of the face to the basic body shape.

Draw thick legs around the wireframes and a tail with a frayed end. Add the finishing features of the hip at the top of the rear and the hanging belly.

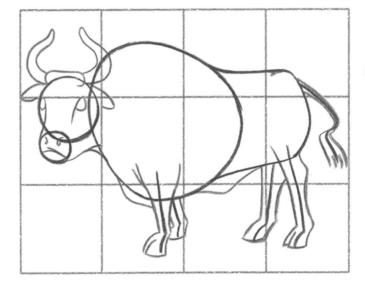

5. Notice the light surrounding the animal. Refer to the artist tip for the cow earlier.

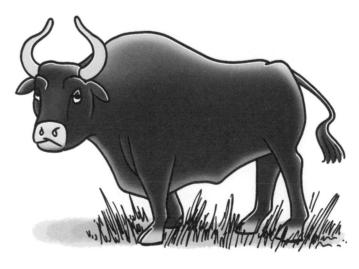

The Pig

Pigs are large bodied animals with big heads and a prominent snout. The snout is used to turn over soil when looking for food. Pigs are known to be intelligent, and stay cool by rolling in mud and water. They are thought to be so sensitive that you can actually hurt their feelings.

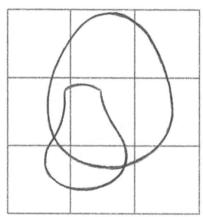

Draw a square grid with three equal squares going across and down.

Begin with a large shape for the body and a pear shape for the head.

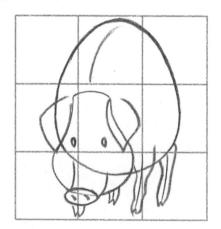

3.

Add the ears and lines to define the snout. Draw the legs around the wireframes and a line down the center of the back.

88

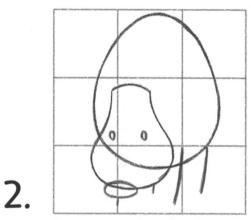

Draw an oval under the pear. Add some eyes in the middle of the pear. Draw in the wire-frame for the legs.

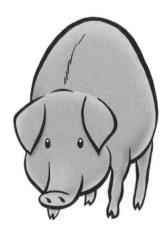

Outline your drawing and erase the pencil lines. Color your pig.

Cartoon Pig

A pig's favorite past time is eating. Making a cartoon character of a pig about to eat a big meal seems only natural. To make it fun we have given him a knife and fork and made him upright, like a human. By adding human features and expressions we can relate to our character, making it as if we can understand how they feel.

1. Draw a grid with two equal squares going across and three down.

This shape starts like a warped egg.

Z. Add a basic shape for the head and back legs. Wireframe arms and feet complete this stage.

3. Add the snout, features and ears. Draw the arms and feet over the wire-frames, making sure to slit the ends for the hooves.

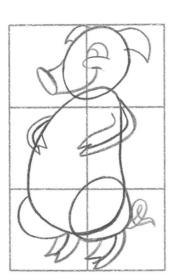

Add a table with some facial food and a knife and fork. Erase the pencil lines and color.

The Rabbit

Rabbits are small furry creatures that live underground in a home called a warren. The tunnels that lead to these warrens are called burrows. Female rabbits can give birth to 30 or 40 babies each year. A group of rabbits is called a herd. Rabbits come to the surface in the morning and at dusk to feed on the grass.

1.

Draw a grid with four equal squares going across and three down.

The body shape resembles an egg on its side. Draw this low on the grid.

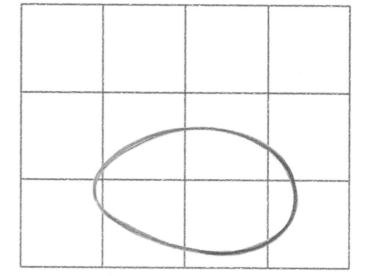

2.

Add the head shape, which also looks like an egg. The back leg is represented with a basic shape. Draw in the semi-circle tail and the wire-frame legs.

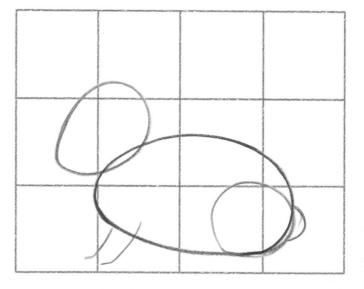

Add on the ears and draw around the wire-frame legs. Add the back foot and finish this stage with the "V" nose, cheeks and eye.

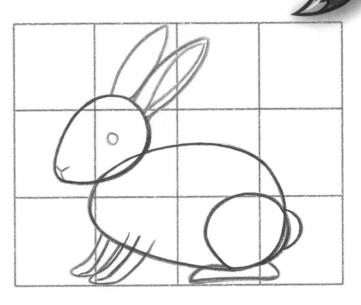

Artist Tip:

To draw whiskers, hair and grass, place your pencil on the paper as you would normally to draw. Flick your pencil while curving it slightly. Repeat this process in a random pattern to fill in the area.

91

4. Remember to leave some of the eye white for a highlight. When the outline is finished and the pencil

outline is finished and the pencil lines erased, add the whiskers on the cheeks.

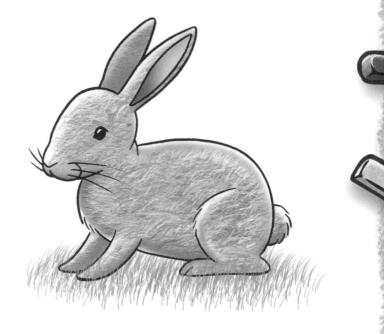

The Horse

The horse has been our working and travelling companion for thousands of years. They were used for pulling chariots in ancient times and carriages in more recent times. On farms they would be used to plough fields. Today, horses are mainly used for show, recreation and racing purposes. There are, however, parts of the world where wild horses still roam.

Ί.

Draw a grid with four equal squares going across and three down.

Start with what looks like a warped jelly bean. This is the horse's body.

2.

Add the wire-frame legs and tail. The wire-frame shows where the bends are.

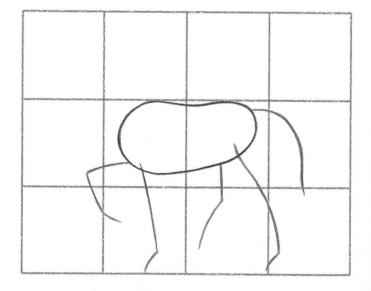

Draw in the neck, mane and head. Add a bushy tail over the wire-frame.

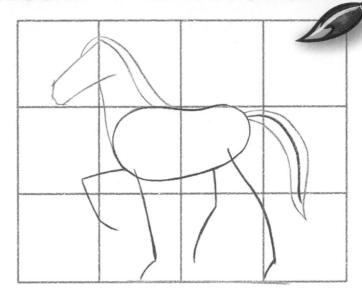

4. Fill in the details of the head and mane, and draw in the legs and hooves.

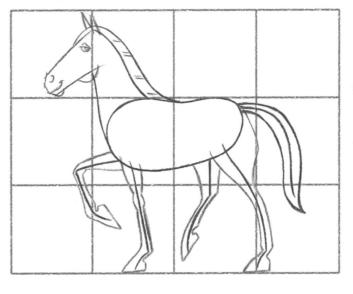

5.

Remember to shade the inside of the legs and under the neck, belly and tail. Leave the edges where the light shines a lighter shade.

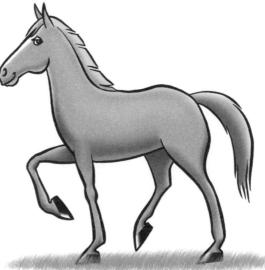

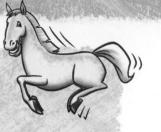

Cartoon Horse

Horse shows involve a lot of jumping and horses can jump very high. What better way to draw a cartoon of a horse than to have it bounding over a jumping pole. Here our horse is happily springing over the high beam with almost no effort at all. This exaggerates their ability to leap.

Draw a grid with four equal squares going across and three down.

Draw in the body shape first. This looks like a flattened egg. Be careful to place it in the correct position on the grid.

Add a long shape rounded at the top and bottom for the head and a circle for the back leg.

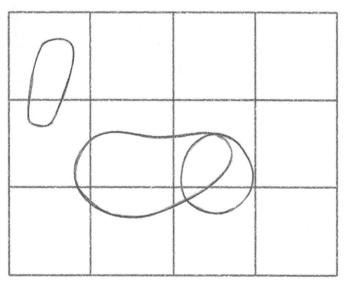

2.

Draw in the lines for the neck and add lines for the wire-frame legs and tail.

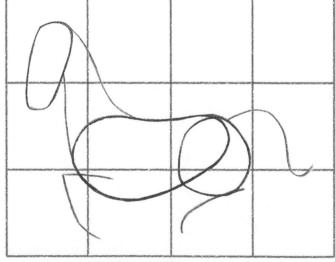

Create the horse over the top of these shapes and wire-frames by adding the ears, mane and facial features.

Draw in the legs. Notice how the legs on the opposite side of the horse are very similar to the legs closest to us. Draw on the tail to finish this stage.

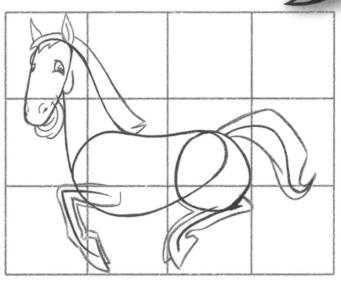

Artist Tip:

Lines around the character can show movement. Lines on the side show it is moving in one direction.

Lines on every side would make it look like the character is shaking, as if it were cold.

4.

Even a white horse has parts where light will not reach. By carefully choosing the parts we shade, we can create a 3-D look while still keeping a white horse. You could have it jumping over a bar, or over one of the other animals in this book.

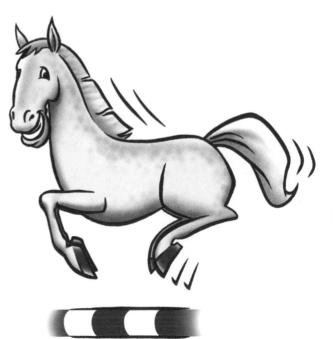

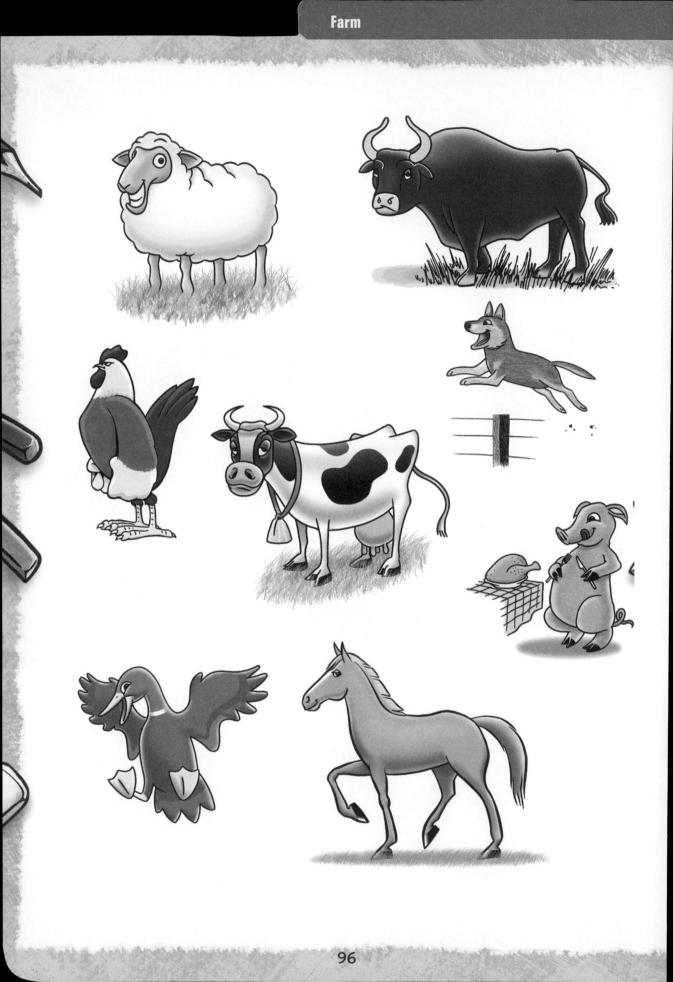

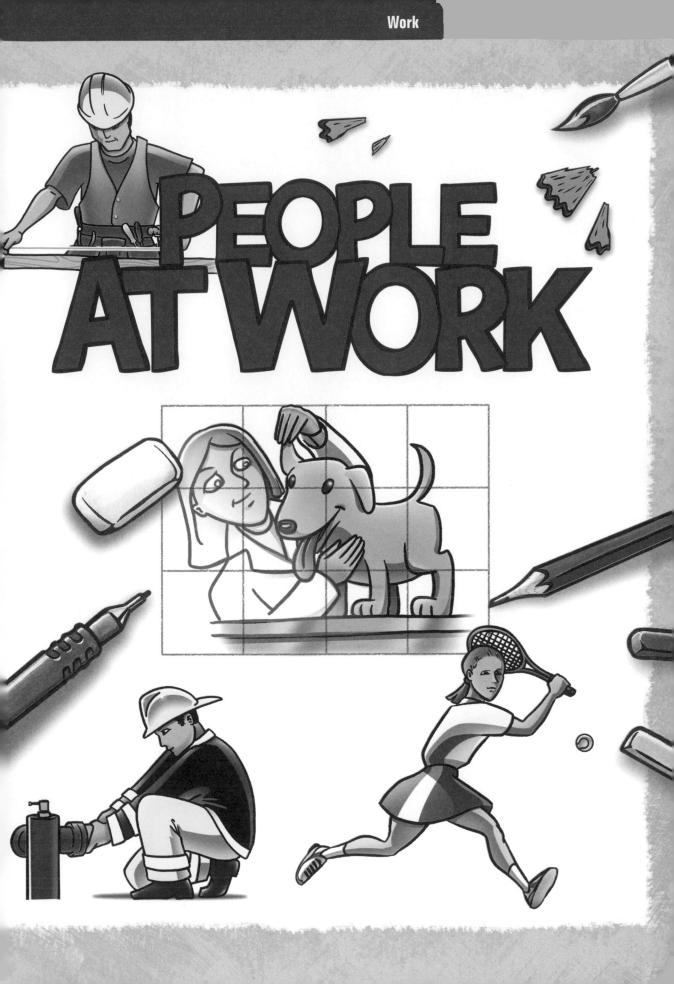

Musician

Musicians play many different types of instruments. They travel from place

to place, writing and performing new songs about their beliefs or aspirations. Many musicians sing, but you don't need to have a good voice to be a musician. Musicians have a talent for playing their instrument and this talent comes from lots and lots of practice.

1.

Begin by drawing a grid with three equal squares going across and down.

Draw in the shapes for the hair and the head at the top and middle of the grid.

\square	

2.

Draw in the facial features. Add the shoulders and the arm. Draw in the shirt sleeves.

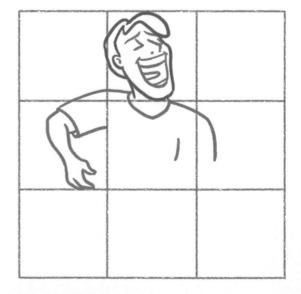

Draw some music notes around his mouth. Draw in the guitar.

4.

Add the hand that's curved around the guitar and the trousers underneath.

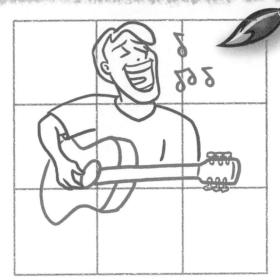

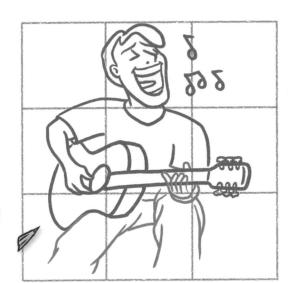

29

5.

Outline and color in your drawing. Musicians don't wear any specific colored clothes so you could color him in any way you like.

Firefighter

Firefighters are there to help protect the community. As soon as they hear of a fire, they put on their uniform and race to the scene. Firefighters don't only extinguish fires, they also help out in other emergencies, like when a cat is stuck up a tree or a car accident has happened.

1.

Begin by drawing a grid with three equal squares going across and down.

Draw in the firefighter's hat and the outline of his face. Draw in the collar of his coat and his arm.

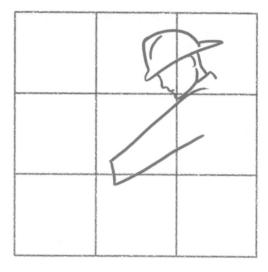

2.

Add the shape for his hand and the fire hydrant. Draw in his other arm and the bottom of his collar.

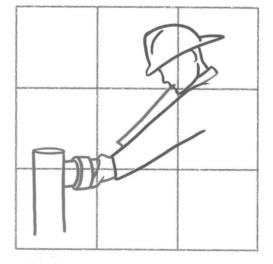

Finish off the details for the hydrant. Draw a long curved line for his back. Draw in his leg and shoe.

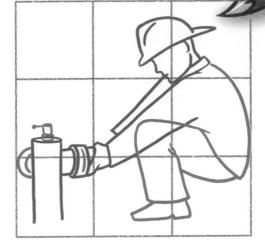

4. Add in his eye and his hair. Draw the line for the inside of his ear. Add the reflective stripes on his jacket. Draw in his other leg and shoe with his knee on the ground.

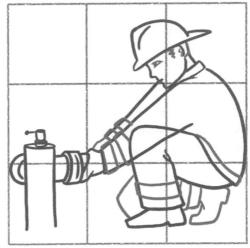

5. Outline your drawing and color it in.

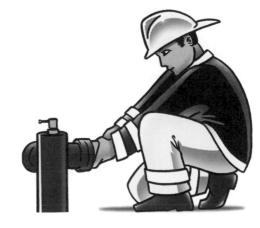

Builder

Builders make everything from large skyscrapers to the houses

we live in. They use many different tools to cut, drill and measure many pieces that fit together to make up a structure. They also organize teams of tradespeople for their project. Builders get up early in the morning so they can get a full day's work in. Building can often be hard work.

1.

Begin by drawing a grid with three equal squares going across and down.

Draw a circle for his protective hat. Add a line around it for the peak. Draw in the shape of his face and neck.

2.

Add the eyes, nose and mouth. Draw in the t-shirt and arms. Notice the position of the hands.

3.

4.

your own.

Draw the curved lines for the middle of his hat. Draw his overalls over his t-shirt. Add a curve at his left hand for the tape-measure and a long line going to his right hand. Draw in the lines for the long piece of timber.

Draw his tool belt around his waist. You may like to add some tools of

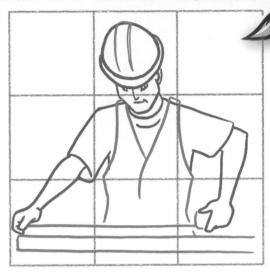

5.

Color in your builder. Notice how there are some wavy lines on the timber to make it look like wood grain.

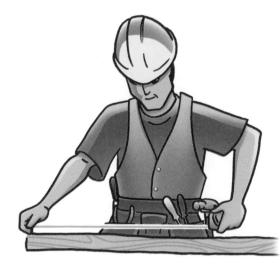

Camera Man

The camera man operates the video camera, trying to get the best view of the action to interest the viewer at home. Sometimes they have to have a lot of patience, especially when filming children and animals, because they can be unpredictable.

1.

Begin by drawing a grid with three equal squares going across and down.

Next, draw some circles for the lens. Make sure they are in the correct position on the grid.

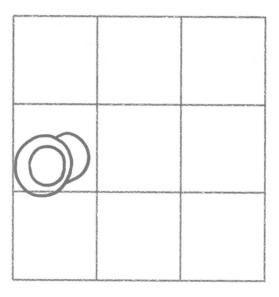

2.

Draw the camera around the lens.

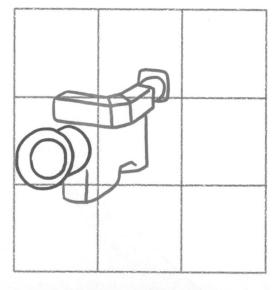

3.

Draw the shape for the hand at the front of the camera. Add the microphone on the side and the handle at the back. Draw in the shapes for the man's head and hair.

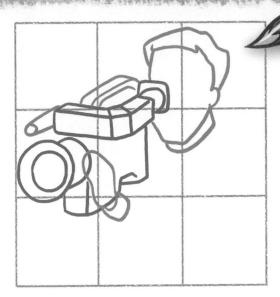

4.

Draw the facial features. Add some lines to separate the hand into fingers. Draw in his jacket.

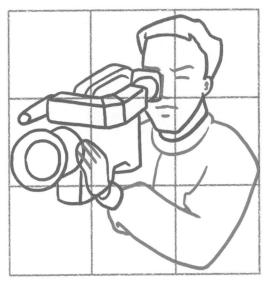

5.

Color in your camera man to finish. Notice how the camera is black, but not totally black. This is because even black reflects light and in turn appears light or gray in parts.

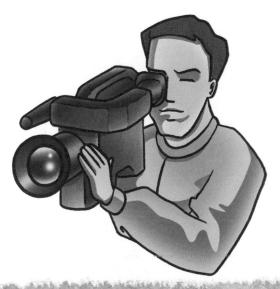

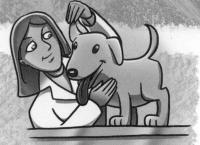

Vet

Vets are like doctors for your pets. They check your dog's

pulse or your cat's temperature and give them medicine if they are sick. Vets know a lot about animals, how they behave and where all their organs are. Sometimes if your pet is really sick the vet comes to you. Vets really like animals.

1.

Begin by drawing a grid with four equal squares going across and three down.

Draw in the shapes for the vet's head and hair. Draw the shape for the dog's head and ear.

2.

Add her facial features and the top of her coat. Draw in the dog's tongue and his eyes and nose. Draw the vet's hand and coat sleeve above the dog's head.

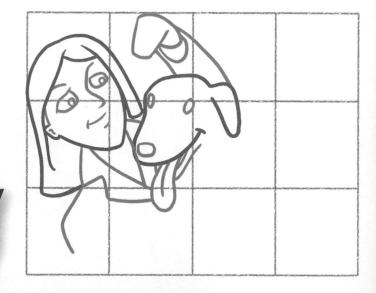

3.

Draw the dog's other ear, joining up to the vet's hand shape. Add a curved line for her shirt under her chin. Draw in the lines for the table top. Add the vet's arm and hand shape. Draw the shape for the dog's body to finish this stage.

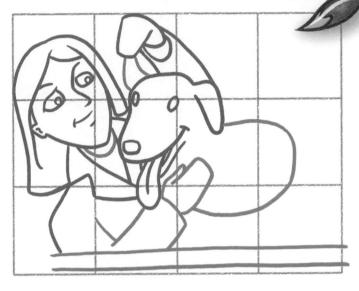

4.

Define the hands with lines for the fingers. Add the highlight points in the dog's eyes and nose. Draw the dog's legs and tail to finish.

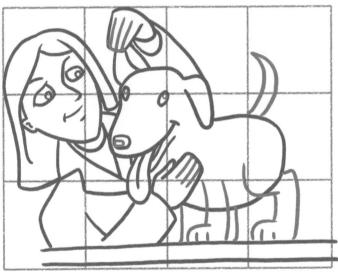

Outline and color in your drawing. The vet's coat is white, so to make her stand out better the background is colored gray.

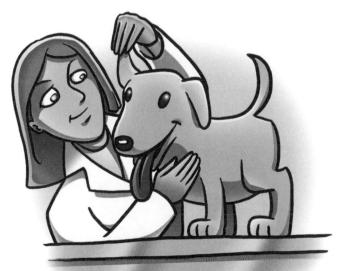

Tennis Player

Tennis players are athletes. They train really hard to be the best they can. When a player gets to the professional stage, they will travel all over the world. They will play tennis against other competitors and try to win various competitions. Tennis is a fun game to play with your friends.

1.

Begin by drawing a grid with three equal squares going across and down.

Draw in the wire-frame with shapes for the head and hands. Add the shoes.

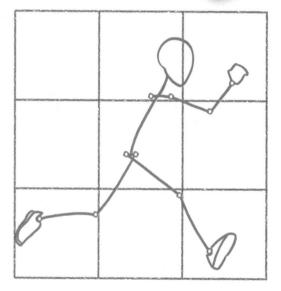

2.

Draw in the shape for the body and the tennis racquet. Draw a small circle for the ball.

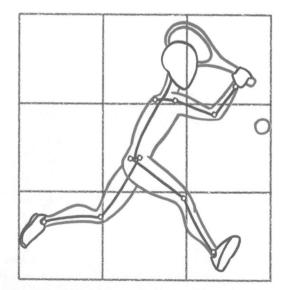

3.

Draw her clothes over the top of her body. Add the details for her face and hair. Draw in the crisscrossed lines for the racquet strings. Put in some curved lines for her socks to finish.

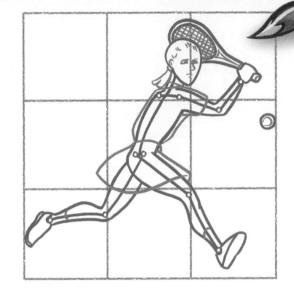

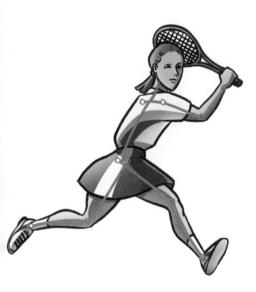

Artist Tip:

The orange lines on this girl are called "wire-frames". These wire-frames are a simplified version of a skeleton. The lines represent the bones and the circles represent the joints. If we can understand the size of the parts of the skeleton and how it moves, we can build our subject around it and it will look natural. There are often three stages to this. Look at the tennis player stages in this book and you will see the skeleton is drawn first, followed by the body and then the clothes over the top.

4.

Outline your drawing and color it in. Tennis players wear many different outfits. You make like to try different color combinations and even design your own clothes.

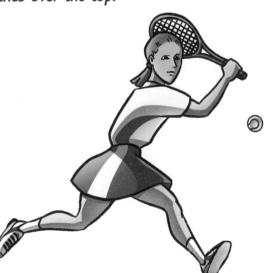

Doctor & Nurse

Doctors are there to help us get well when we are sick. They know a lot about how our body works, so if something goes wrong they know the best way to fix it. Nurses help the doctor take care of us when we're in hospital. They check on you every so often to make sure everything is going okay.

1.

Begin by drawing a grid with three equal squares going across and down.

Draw in the rectangular shape for the clipboard. Draw in the shapes for the doctor's body, arms, head and hair.

2.

Add the mirror on top of his head. Draw in his facial features and the stethescope around his neck. Add the hand holding on to the clipboard, his legs and his shoes. Draw a line down the middle for his coat.

3.

Draw the collar for his coat. Draw in the nurse, paying close attention to the point where she intersects the grid lines.

4.

Add her hat and her mischievous facial features. Finish by drawing in the syringe.

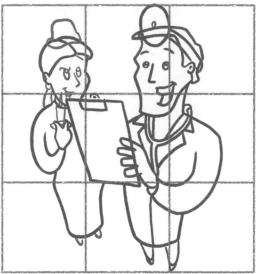

5.

Outline and color your doctor and nurse.

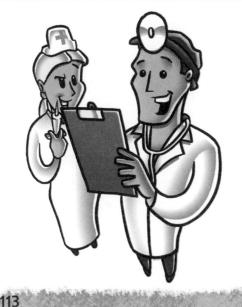

Policeman

The police have a very important role in our society. Their main job is to maintain order, fight crime and patrol the neighborhood to make sure everyone is safe. Sometimes they do other jobs, like direct traffic. You're not allowed to have a criminal record if you want to become a policeman.

1.

Begin by drawing a grid with three equal squares going across and down.

Draw in the shape for the cheeks, small ear and hat peak. Add his mouth and the lines for his shoulders.

2.

Draw in his hat. Add half-circle curves under the peak of his hat for his eyes. Draw in a zig-zag line for some hair. Add his long, curved arms and body.

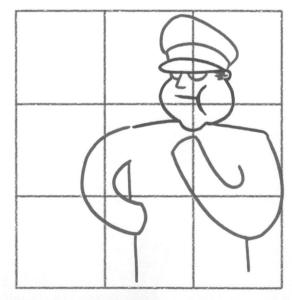

Draw the police symbol on his hat. Draw the lines for the checkered pattern on his hat. Add his collar and his hand holding the whistle. Draw in his other hands with the movement marks. Finish with the buttons and coat line.

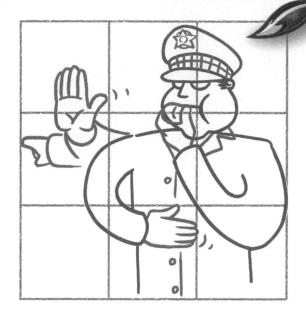

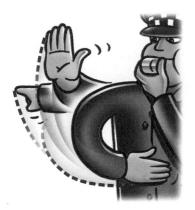

Artist Tip:

Drawings, like photos, are still pictures. They cannot move. We can, however, portray movement by drawing lots of the same thing. Here we have drawn three right hands. This shows he is moving it very quickly. This is further shown in the arcs highlighted by the dotted lines. These arcs are lightly colored with the same color as where his hand and clothes have been. Try waving your hand quickly in front of your face to see the arc and how many hands you can count.

4. Outline your drawing and color it in. This policeman is wearing a blue uniform but some policemen wear black.

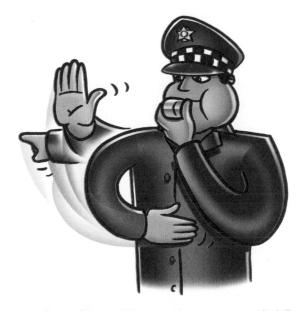

Astronaut

Astronauts get to pilot big spaceships and dress up in space suits. Some even get to go to the moon. They have to go

through lots of training to be prepared, in case anything goes wrong when they are in space. The astronaut you're about to draw is holding a really heavy weight, because on the moon there isn't as much gravity so things don't seem to weigh much at all.

1.

Begin by drawing a grid with three equal squares going across and down.

Continue by drawing the circles for the helmet high on the right side of the grid. Notice the circle inside the helmet is slightly squashed. Draw another circle for the Earth and a big arc at the bottom for the moon.

2.

Draw the wire-frame for the astronaut's body (see the Artists Tip for the tennis player about "wireframes"). This is the basis of our character. Draw his hands at the end of these.

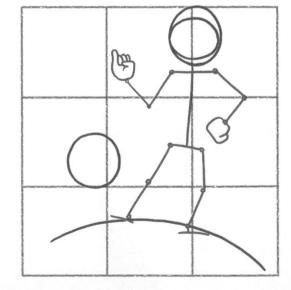

Add the space suit over the wireframe making it fairly puffy. Draw in the panels on his torso.

4

Draw the barbell on top of his finger. Draw the face inside the helmet. Add some lines for his backpack. Draw in the clouds and countries on the Earth and the craters on the moon.

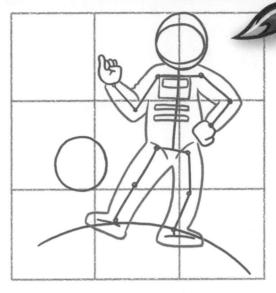

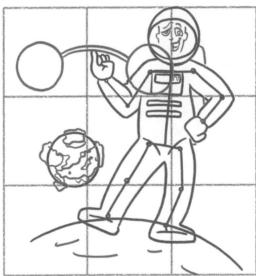

Outline and color in. You can color the background black and use dabs of white paint or correction pen for the stars. Here we have put a shadow under him to show he is slightly off the face of the moon. This highlights the weightlessness.

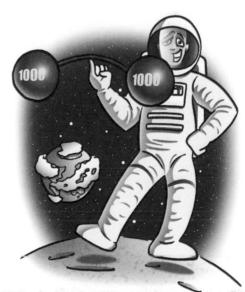

Artist

An artist spends lots of time creating their art work. They understand what colors look the

best together and creatively arrange them in some sort of picture to look amazing. A typical artist has an easel on which they paint or draw. Some artists don't become famous until long after they have died.

1.

Begin by drawing a grid with three equal squares going across and down.

First draw the peanut-like shape for the head. Add the curved lines for the arms and hand. Finish this stage by drawing in the rest of the body. Check that everything is in the correct position on the grid.

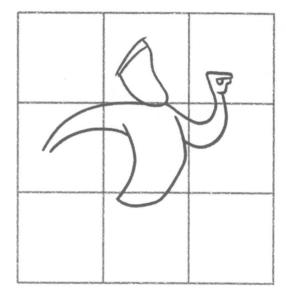

2.

Draw the hat on top of the head shape. Draw the skewed rectangle shape for his canvas. Add a shape for the hand. Draw an arc for the legs. Make sure they go from being thin at the bottom to thicker at the top.

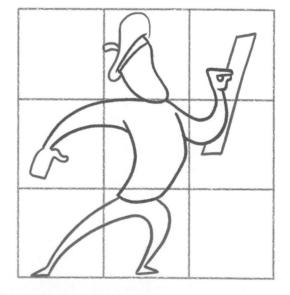

Draw in the facial features. Separate the hand shape with lines for the fingers. Draw the legs for the easel.

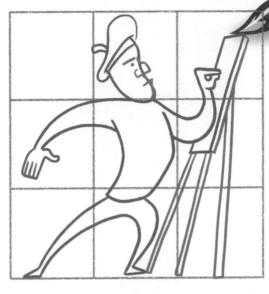

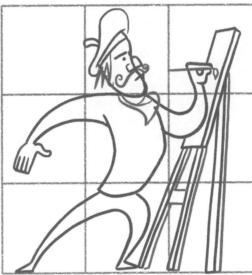

4.

Draw some hair coming out from under his hat. Add the moustache. Draw the paint brush in his hand and finish with the rest of the lines for the easel.

5.

Outline your drawing and color it in. You can make the artist's clothes any color you like. Don't forget to draw in a work of art on the easel!

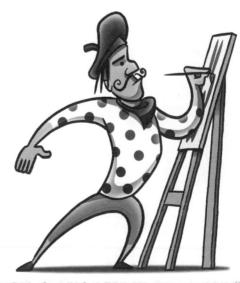

Contents

Truck 124

Super Car 126

Sports Car 128

Rally Car 130

Motorcycle 132

Truck

With their loud deep horns, huge wheels and big engines, trucks are the biggest vehicles on our roads. They range in size

from the lighter delivery trucks to the 18-wheel semi-trailers. Most trucks have a horn that you pull down, rather than press with your finger. Their main use is to transport goods. The largest truck in the world can carry around 400 tons!

1.

Begin by drawing a grid with three equal squares going across and down.

Start by drawing the squarish shapes in the correct position on the grid.

2.

Draw the truck's grill and light panels. Draw in the two windscreen windows. Define the cabin and add the side window.

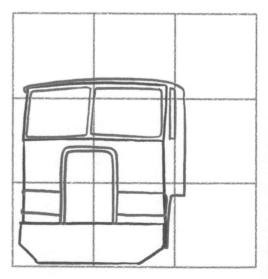

Draw the lines for the grill. Add the headlights and place for the licence plate. Draw in the exhaust pipes, horns, lights and the windbreak on the roof.

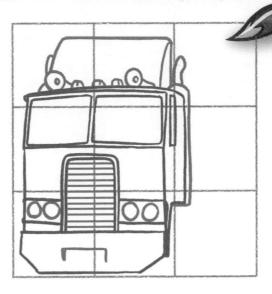

4

Finish by drawing the trailer. Make sure your truck's wheels are tall and skinny.

5.

Outline your drawing and erase the pencil lines. Color your drawing. The graphics on trucks have lots of different patterns. Maybe you could invent some of your own for the front and side of your truck.

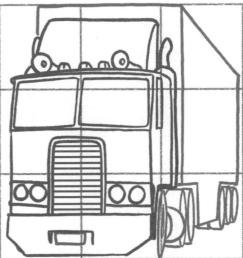

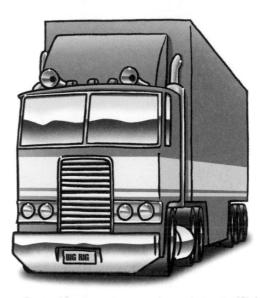

Super Car

Super cars are the cars people dream about owning. A lot of time is put into designing them so that they look really good and have powerful engines. They have an aerodynamic body so they can cut through the air, like an airplane. Super cars are very fast and very, very expensive.

1.

Begin by drawing a grid with four equal squares going across and two down.

Draw in the long, curved shape highest on the grid. Draw in the bottom curve, taking notice of the kinks at the corners of the triangle. Put in the lines to make the two triangles.

2.

Draw in the angled lights and air intake at the front of the car. Draw the parts of the front tires that are visible. Draw in the wheels at the side and the line between them.

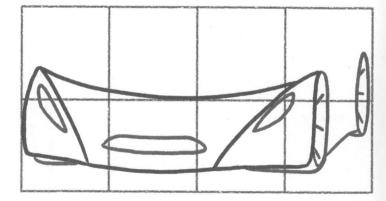

Draw in the small air intakes in the front triangles. Add in the rounded shape for the windscreen. Draw in the line for the side and add the side air intake.

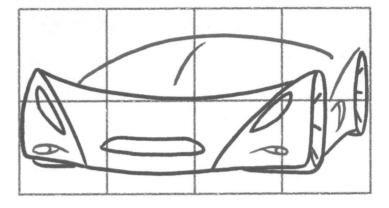

4. Draw on the wing at the rear of the car to finish.

Outline your super car and erase the pencil lines. Color your drawing. Red is often associated with speed and works well on this super car.

5.

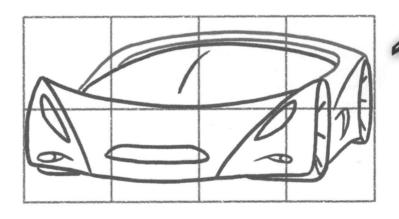

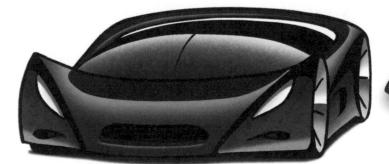

Sports Car

Sports cars are low, designed for quick response and good handling. They generally have two doors, two seats and a roof that can be taken off. Sport cars are made for luxury, with all the latest car gizmos and gadgets. A sports car is really fun to drive on a nice sunny day.

1.

Begin by drawing a grid with four equal squares going across and three down.

Then draw the side of the car and a little of the front.

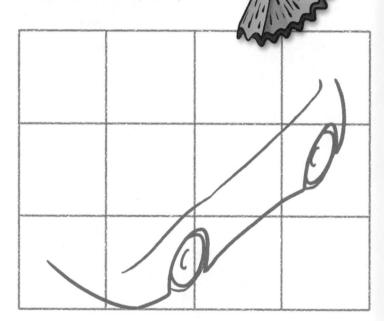

2.

Continue to draw the rest of the body and windscreen. Add the side mirror.

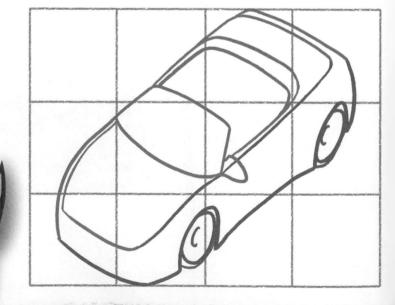

Add the lights and front grill. Define the windscreen and bonnet details. Add the far side mirror and seats. Draw in the door lines and handles. Finish by adding sporty shapes for the wheels.

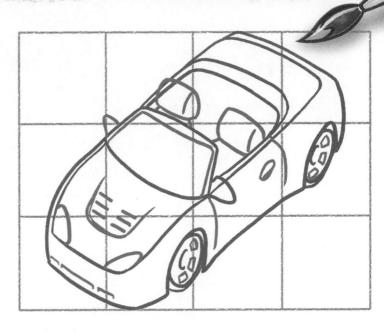

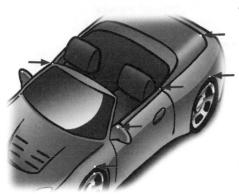

Artist Tip:

Light is reflected best on corners. Here we have added little light spots on some of the corners of the car to help it look shiny. To add these hightlights, color your whole car first and then look for little corners to highlight with a white dot. You can use white paint or even a correction pen for this. Little details like light-spot reflections can greatly enhance our drawings.

different colors. This one is green, but you could make it any color you like.

Rally Car

Rally cars are off-road racers, driving at incredible speeds through mud, snow and gravel. The navigator sits next to the driver, giving instructions on how to take the next turn. A lot of time is spent sideways and making split-second decisions about where to steer the car. Rally drivers have great reflexes.

1.

Begin by drawing a grid with four equal squares going across and three down.

Now, draw in the bumper bar and lights. Add the tight arch where the wheel will be.

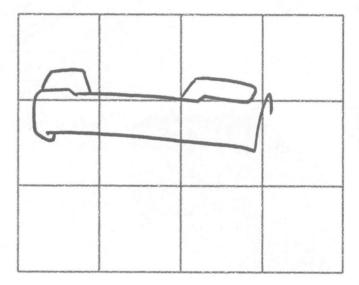

2.

Draw on the details on the bumper bar and grill. Add a curved line for the bonnet and the windscreen above.

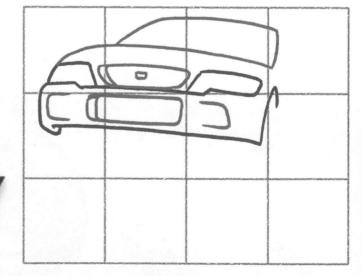

Draw the fog lights on the bumper. Draw the front wheel and body side.

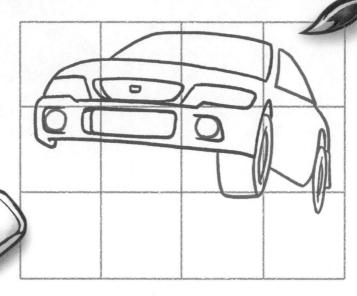

4.

Draw the roof line to the side window. Add lines for the doors and the door handles. Draw the top of the drivers' helmets. Add on the bonnet lines. Draw the shape for the rear wing. Draw in the underneath of the car and the rough ground below.

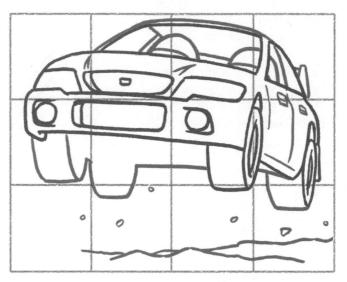

5.

Here I have made up a color scheme and number for the rally car. You could make up your own pattern and put your favorite number on it.

131

Motorcycle (

There are a few different types of motorcycles, such as off-road and touring motorcycles. Not all of them have two wheels – some types come with three or four. Motorcycles are very zippy compared to cars. They don't use much fuel and are very easy to park, which makes them great for transport. Motorbikes are lots of fun!

1.

Begin by drawing a grid with four equal squares going across and three down.

First draw the body shape, being careful to construct the lines in their correct place on the grid. Add in the exhaust pipe.

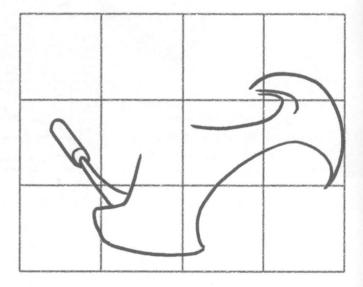

2.

Draw the leg first, followed by the arm and hand. Draw the line for the top of the petrol tank. Draw on the cross-arm under the leg shape. Draw the piece of fork under the body.

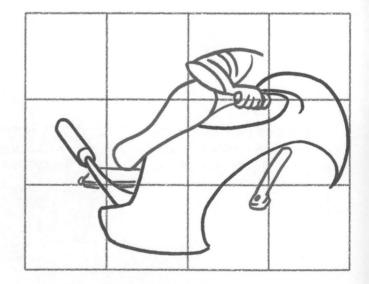

3

Define the knee pad and boot with some curved lines on the leg. Draw in the rear and front wheels and details.

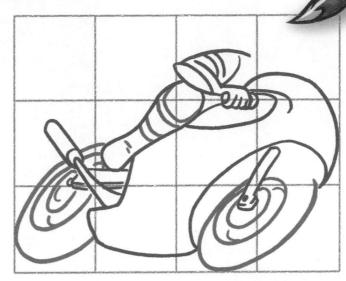

4.

Draw the helmet. Next, draw a line through the top of the body for the visor. Draw in the wheel cover on the front wheel. Add the rear and the seat of the bike. Finish by putting in the drive chain near the back wheel.

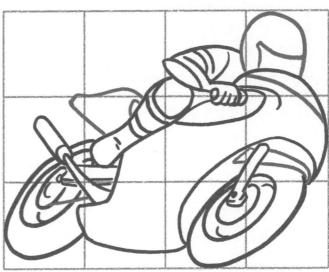

133

5.

Here we have designed a simple pattern and a made-up sponsor for our racing bike. See if you can come up with a pattern and sponsor for your bike.

Model T

In the early 1900s, cars were just toys for really rich people. Henry Ford thought it would be a good idea if almost everyone could afford a car. So in 1908 he released the Model T, a car that was affordable for the average American. Henry Ford sold a lot of his cars and by 1914, he had made more cars than any other company.

1.

Begin by drawing a grid with four equal squares going across and three down.

Start with the roof and windows. Notice the curved line for the beginning of the bonnet.

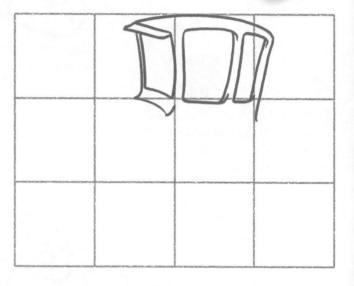

2.

Draw in the bonnet lines and the light. Add the grill. Finish this stage with the wheel covers.

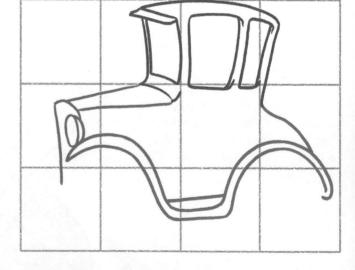

Draw in the wheels. Add the far headlight, grill line and wheel cover. Draw in the spare tire on the rear and the door handle.

4. Draw in the door lines and the spokes for the wheels.

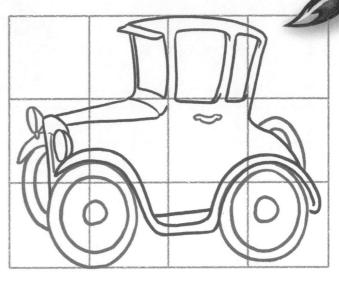

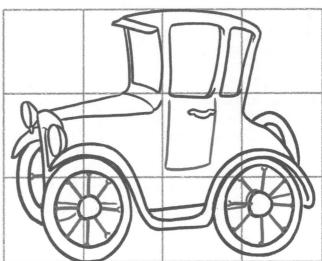

Here we have colored the Model T black. This was a common color for the early car. If we had colored it completely black however, it would look like a black blob. By adding some white light reflections the car still looks black, but the different parts can be seen.

135

Custom Car

A lot of time and money is spent on these cars to make them look, sound, feel and run at peak performance. These cars are entered in shows and various competitions against other custom cars. Shiny paint jobs, big mag wheels and engines that poke out of the bonnet are typical features of a custom car. This type of car is made for its "wow" factor.

1.

Begin by drawing a grid with four equal squares going across and three down.

Now start drawing in the bumper bar. Add the indicator lights and the arc for the grill area. Draw in the wheel arch and front wheel. Draw in the rest of the body and the rear wheel.

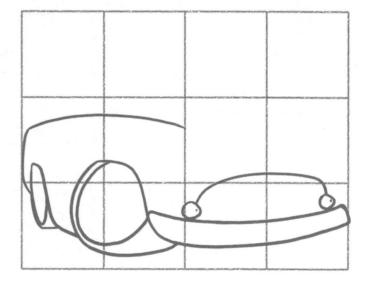

2.

Draw in the lights' circles. Draw the pieces for the grill and inside areas. Add the body shape above the grill and the engine parts. Add the detail on the inside of the wheels.

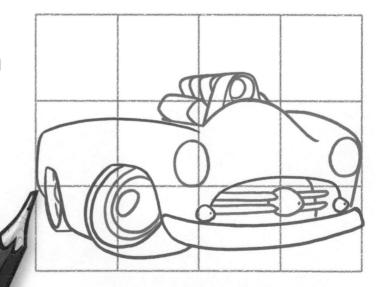

Draw in the rest of the engine parts. Add the reflection lines in the lights and the circle in the grill. Draw the roof and windows. Finish with some short lines for the doors and get ready to outline.

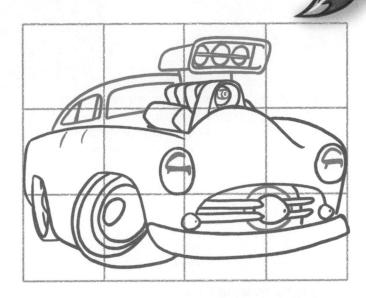

Artist Tip:

There are a few secrets to drawing great cartoony cars. They are:

- 1. When drawing the side, have the distance between the wheels as close as possible, while still maintaining the normal wheel size.
- 2. Make the body really tall.
- 3. Make the side windows and roof line really short.

These simple but effective principles will have you cartooning great cars in no time!

4.

Color your car. Study the metal parts closely. A light blue color on top that fades into white, a black line through the middle and a dark gray that fades make it look shiny.

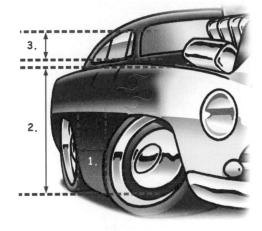

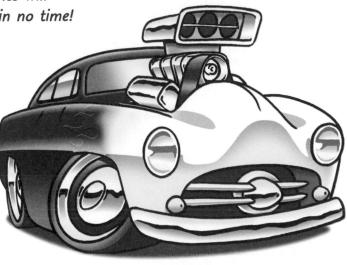

137

4x4

Real 4x4s are off-road cars. Jacked up high with added suspension and monster wheels, they force their way over huge obstacles and up really steep hills. "Four-wheel drive" means that if two wheels are bogged in mud, the other two can pull the car free. A stop at the car wash is often needed after the 4x4 has been through the mud all day.

Begin by drawing a grid with three equal squares going across and down.

Next, draw the wheels. Notice how they are on different angles to each other. Draw in the rocky ground. Check to make sure you have placed everything correctly on your grid.

2.

Draw in the other front wheel. Draw the bumper bar and wheel arches. Add the line across the bottom of the truck and the rear wheel arch.

Draw in the bonnet and cabin structure. Add the side window shape and the bottom door line going into the rear wheel arch cover.

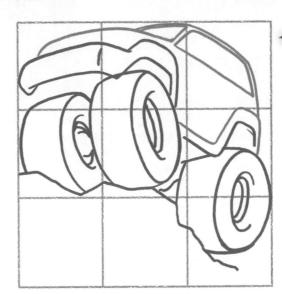

Draw in the grill and lights. Add the licence plate area. Divide the side window into individual windows and add door lines. Finish with the door handles.

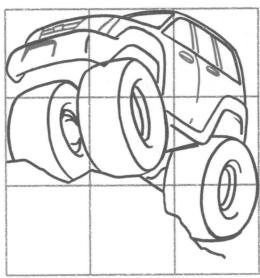

5.

Outline your drawing and erase the pencil lines. You could draw some more of the rocky road here or even put the car on top of a really high mountain.

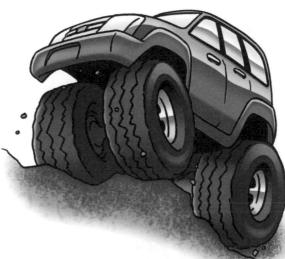

A Formula 1 car is very expensive.

Formula 1

Loads of time is spent designing and maintaining these cars to make them as fast as possible. Millions of dollars are spent before a Formula 1 team wins an event. Formula 1 drivers have to know their car really well so they can speed around the track as fast as possible. A Formula 1 car can go over 185 miles per hour!

1.

Begin by drawing a grid with three equal squares going across and down.

Draw a rounded "V" for the nose cone. Add the wings either side.

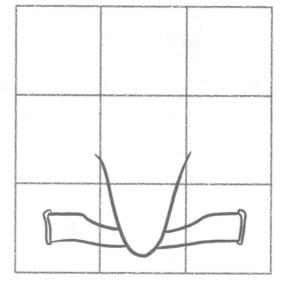

2.

Draw the wheels either side and parts of the air intakes beside them. Add the curved shape for the cabin opening.

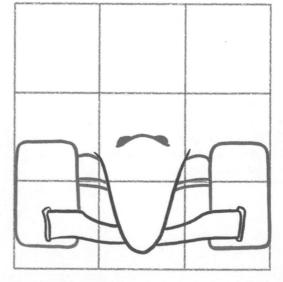

Draw in the helmet and central air intake above the driver's head. Add the mirrors on either side. Draw the body shape to finish this stage.

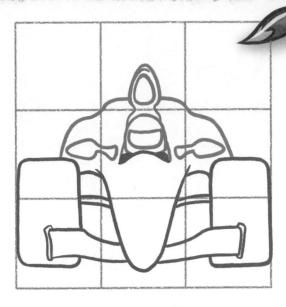

2

4

Draw in the rear wing and wheel wings. Add the back wheels. Draw in the steering rod lines to the front wheels to finish.

5.

Here we have colored the car with a simple color scheme of orange and white. You could invent your own color scheme and even your own team design, and also put it on the truck, rally car and motorcycle pictures in this book.

141

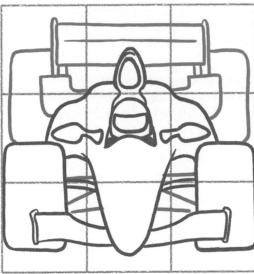

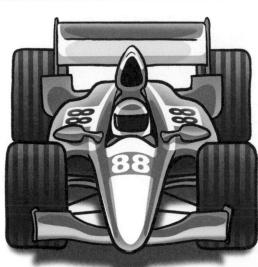

Van

Vans make good family cars because they have room for all

the people and their gear. Most vans have the engine underneath the driver and front passenger. Sometimes if people want to carry something really big, they fold down the back seats so they can fit the large object in.

1.

Begin by drawing a grid with four equal squares going across and three down.

Start by drawing the entire outside shape of the van. Be careful to note where each line intersects the grid lines.

2.

Draw in the curved rectangle side door. Add the round shape for the windscreen which comes to a point at the front. Draw in the dashboard and small air intakes at the bottom of the car's front.

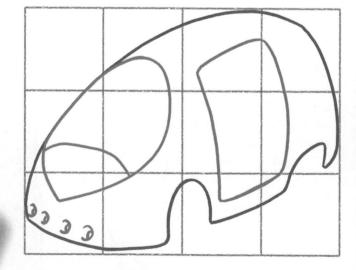

Draw in the wheels and side mirrors. Add lines to define the front lights. Draw in the steering wheel.

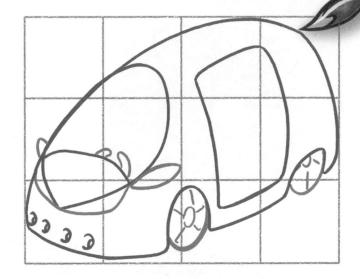

4.

Draw the two curving lines for the side window. The top one carries on over the windscreen. Add the seats to finish.

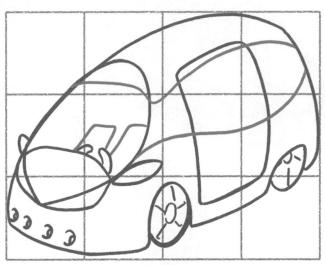

5.

Outline your drawing, erase the pencil lines and color. See if you can make up a futuristic town the van could be driving through.

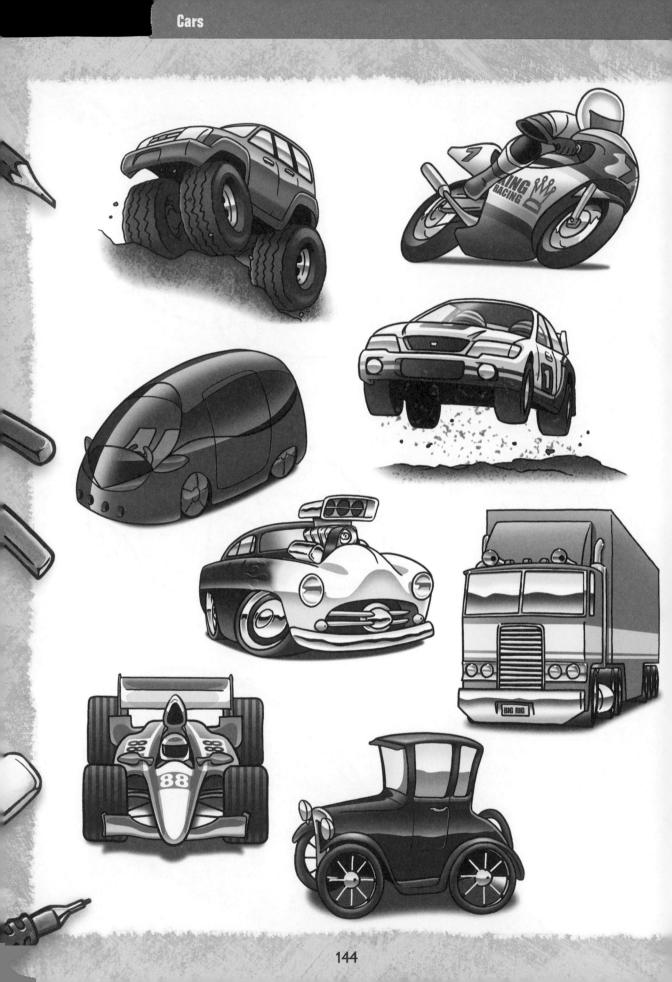

Cartoon Contents Sporty Grandma .. 148 Pirate 150 Cute Girl 152 Mad Scientist 154

Sheriff 156

Sporty Grandma

Grannies are often thought to be fragile and content, relaxing in a rocking chair. Cartooning allows us the freedom to go outside the normal boundaries of reality and make characters do things they never would do. So what better way to do this than to have granny busting out on a fast break in a basketball game?

1.

Begin by drawing a grid with three equal squares going across and down.

Draw in the eyes and the eyebrows. Add the small nose and ear.

Draw in the cheeks and chin.

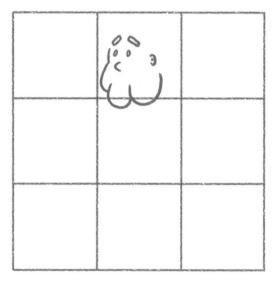

2.

Add the hair and mouth. Draw the frills around her neck and the arms.

Draw the frills at the end of her arms, and cone shapes going down to her hands. Notice how simple the hands are. Draw them in.

Complete the rest of this stage by drawing clothes and buttons.

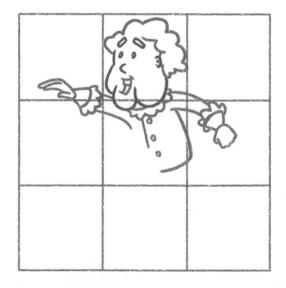

Draw in the basketball and put a rounded cross on it.

Add the dress and the thin legs coming out from it. Check your drawing is correct and move on to the next stage.

Draw in the round lines on the ball. Add her glasses and her handbag. Draw the shoes and the dust-puff lines to show that she's moving quickly. Add the rounded movement lines to finish the stage.

5. Grannies usually have gray or white hair. They do not usually wear bright energetic colors, but since this is a cartoon, you could make her any color you like. Happy coloring!

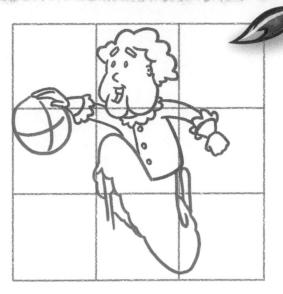

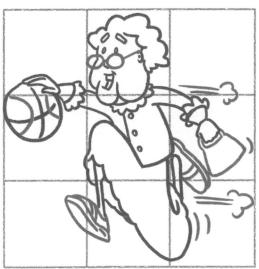

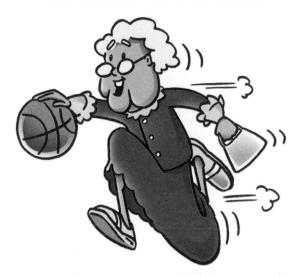

Pirate

Pirates are mean seafarers who are well known for their rough looks and attitudes. Wooden legs, hooks for hands and eye patches are commonly associated with pirates.

1.

Begin by drawing a grid with three equal squares going across and down.

Draw in the eye and eyebrow followed by the nose. Draw in the other eye patch. Draw the ear and the large beard around to his eye patch.

2.

Draw in the mouth and the head scarf: add the jacket top and the arms. Study the hands so you can draw them correctly.

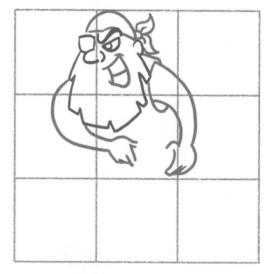

Draw in the sword and sheath.

Add the rest of the jacket. Draw in the trousers. Add the shape for the top of the boot.

4.

Black out some teeth and add his wooden leg. Draw in the rest of his boot to finish this stage.

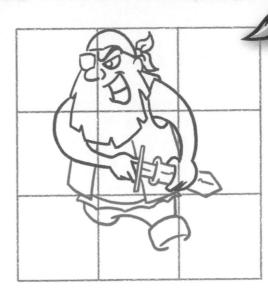

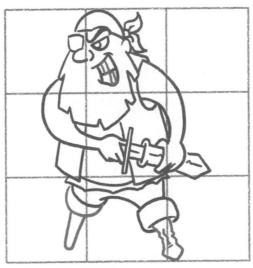

5.

You could have this pirate standing on the deck of his ship, ready for a sword fight.

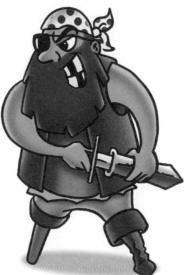

Cute Girl

Innocence and simplicity is often associated with cuteness. A happygo-lucky personality and a love of life go hand in hand with this type of character. Shrugged shoulders and slightly pointed-in feet emphasize this attitude.

1.

Begin by drawing a grid with two equal squares going across and four down.

Draw in the eyes first and then the small eyebrows. Add the shape of the cheeks and face. Draw in the hair line. Draw the neck and finish this stage with the little nose.

2.

Add in the top of the hair and the mouth. Draw the hand on the mouth and then the arm.

Draw the t-shirt and curved lines for the hips and legs.

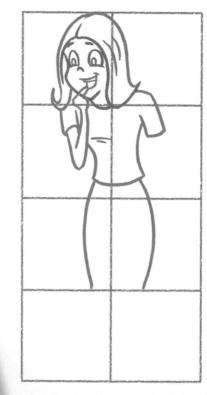

Draw in the arm and hand. Study the hand here to see how simple it is.

Add the rest of the skirt and the legs and feet.

4.

When outlining your drawing, be careful to only ink the lines you need. Color to your heart's content. You may even want to put a different pattern on the skirt.

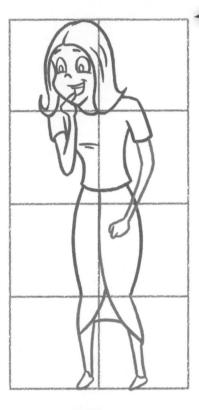

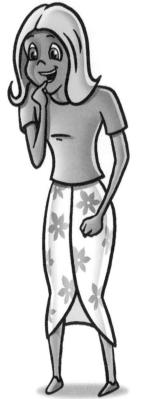

Mad Scientist

Working deep in his secret laboratory, this chemical cocktail-making madman is growing more insane with each devious thought. He is obsessed with his plan to take over the world. Wild hair and a torn lab coat are the result of past experiments gone wrong. Could this be the moment before this mad scientist's next unfortunate event?

1.

Begin by drawing a grid with three equal squares going across and down.

Start this stage by drawing the closed eye's eyebrow. Draw in the line for the closed eye and surrounding cheek and brow. Draw in the other eye and add the nose. Draw in the ear and mouth. Check that everything looks correct before moving on to the next stage.

2.

Draw in the beard and underneath part of the open eye. Add the eyelid above the eye. Draw some crazy hair all around from his brow to his beard. Finish this stage by drawing in the curved arm.

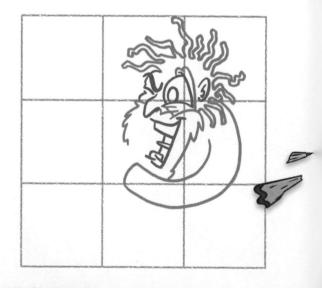

Draw the hand and test tube. Add the collar of his lab coat and the flared-out bottom of it on either side. Draw in his legs and tiny feet.

4.

Draw in the other test tube and hand. Draw in his torn coat arm right up to his brow. Add the steam to finish this stage.

5.

Could the green on this scientist be a reflection of the nuclear ooze glowing from the bench-top he is standing in front of? Or maybe some sort of radiation machine he has invented?

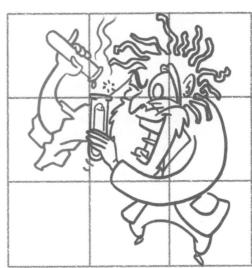

Sheriff

"This 'ere town ain't big enuff for the tew of us, so one of us 'as gotta go!" This sheriff is pumped in a ready stance to take on the outlaws in a quick-draw duel. He relies on his fast reflexes and sharp shooting to maintain justice in the West. Are you ready to draw?

1.

Begin by drawing a grid with four equal squares going across and three down.

Start with a rounded triangle for his hat. Draw the arms in a wide curving arc, starting close to the top of his hat brim. When drawing the arms, make them wider at the top and gradually thinner when they reach the wrist. Draw in his torso and the shape for his face.

2.

Draw in the crown of his hat and his vest. Add the sleeves bunching up at his wrists. Draw in his belt and trousers.

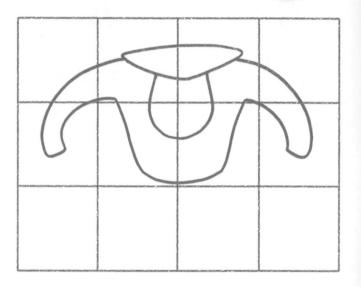

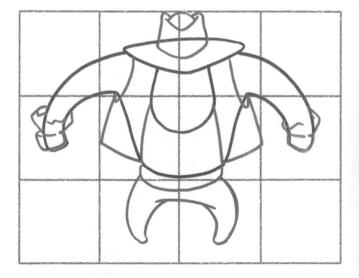

Draw in two half circles under his hat for his eyes. Put in his nose and pushed-up lip. Draw two circles for his badge. Add his gun holsters at his side and the bullets around his belt. Put in his shirt buttons. Draw his ready hands and finish this stage with his feet.

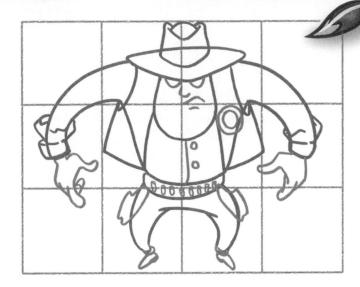

4.

Add the guns in his holsters, with some movement lines around them and his fingers. Draw in the star on his badge. Add some whiskers around his chin and some dots for whiskers on his face. Draw the pupils in his eyes to finish.

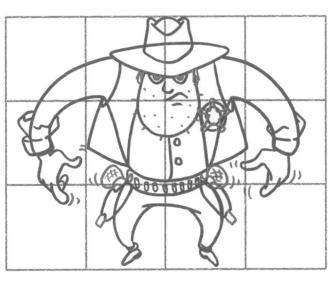

000000

5.

Cowboys wear leather belts, jackets and shoes. These are often tan (light brown) or black. They also often wear blue jeans. The "bad guys" in films often wear black.

Baby

Babies have very distinct features, which makes them great for cartooning. They have huge heads and large eyes. They are very chubby and can often be seen crawling around wearing only a white nappy and sporting a giant safety pin. Their only accessory is a dummy, which is most likely found on the ground beside their pram.

1.

Begin by drawing a grid with three equal squares going across and down.

Draw in a three-quarter circle for the head. Add two shapes for the ears. Draw in the stretched oval shape for the chin.

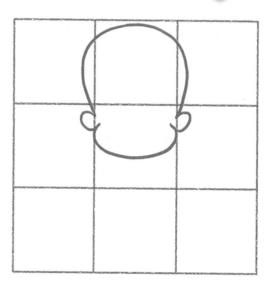

2.

Draw in the big eyes and the eyebrows. Add the little nose and the inside of the ear lines.

Draw the shapes for the feet.

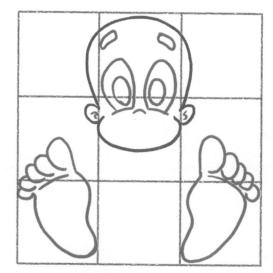

Add the lines on the feet. Draw in the chubby legs and the oval shape for the nappy. Draw two lines up from the nappy for the baby's chest.

4

Draw the shoulders and arms and the bits near the feet. These are the baby's hands.

Draw in the dummy to the right of his face.

Add the safety pin and you're ready to ink!

5.

Babies have blue eyes when they are born. They also wear white nappies. If you look closely, you will notice that the nappy is not perfectly white. By coloring it very lightly with gray or blue, it can still seem white, but more realistic.

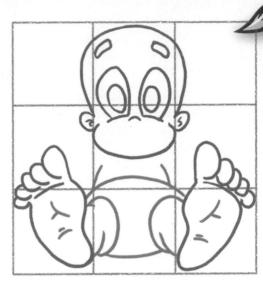

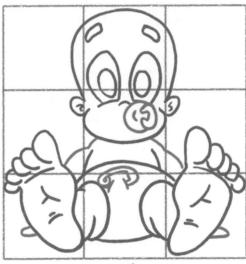

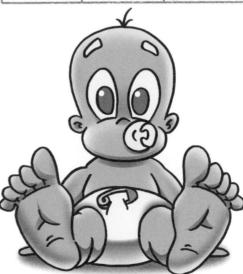

Villain

Evilly inclined, these villains are devious figures. They devise ways to subdue mankind so they can control the world. Their ideas never seem to go as planned because of the hero, who always seems to be present just before the moment the villain will reach glory.

1.

Begin by drawing a grid with two equal squares going across and four down.

Start with the villain's eyes, eyebrows and nose. Add his large rounded brow. Draw in his mouth and ear.

2.

Draw his beard and the top of his head. Add in his huge collar, pointing into a "V" at his chest. Draw his shoulders and his curved arm sleeves. Add thin wrists and a ball for his hands.

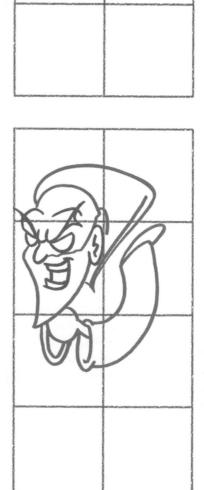

Draw in some squiggly lines for his fingers. Finish off by adding his coat. Notice how it is draped along the floor.

4.

Villains usually wear fancy darker colored clothes. They rarely wear bright colors. This helps them seem more sinister.

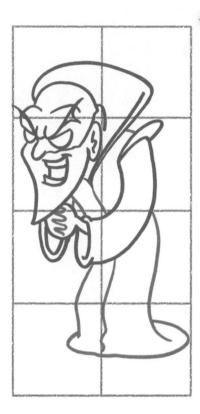

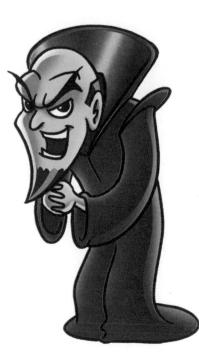

King

These rulers of the medieval world have many personalities. There was nothing more appreciated by the people than a jolly king. They dressed in large, heavy robes

and often wore heavy jewelry such as rings on their fingers. They also carry a large golden rod called a sceptre.

1.

2.

Begin by drawing a grid with three equal squares going across and down.

Draw in the eyes followed by the nose and the mouth. Add the eyebrows to finish this stage.

Draw in the big beard and the puffy material under his chin.

Draw a curved line for his stomach, which flows onto his legs. Add the other leg and his feet. Draw in another curved line going from the puffy material to the back of his hip.

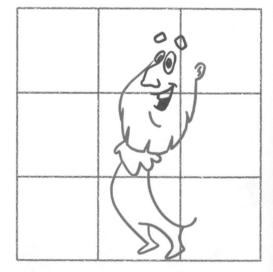

Draw a curved line in front of his stomach for his robe. Add the arm and puffy robe cuff. Draw in the right hand.

Draw the other arm, cuff and hand. Draw in a backward "S" that goes from his ear to the recently drawn hand.

4.

Draw in the sceptre and the crown. Add the spots on the robe. Draw a ring on the king's finger. Draw in the king's vest to finish this stage.

Artist Tip:

In cartooning, we can give our character personality by emphasising

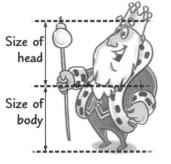

their main features. This good-hearted king makes up in personality what he lacks in height. This personality is emphasized by using his most expressive feature, which is his face and head. Notice how the head is as big as the rest of the body combined. The henchman in this book has a small head because he is not very clever, but a big upper body to emphasize his strength. The henchman's strength is the dominant feature. See if you can design cartoon characters with emphasized attributes.

5.

Kings wore many different colored robes. Red, purple, blue and yellow are considered to be royal colors.

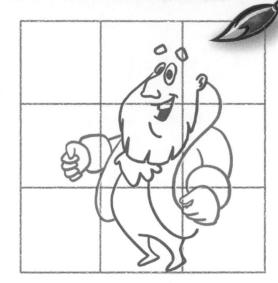

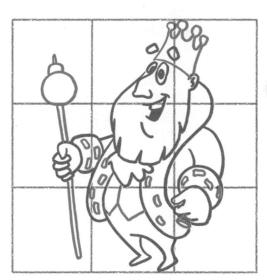

Queen

A jolly king wouldn't be a jolly king without a jolly queen. This queen was made to accompany the drawing of the king in this book. See if you can draw them side by side.

E

1.

Begin by drawing a grid with two squares going across and four down.

Start by drawing in the eyes and nose. Move on to the cheeks and chin. Draw in the three-quarter circle for the earring. Draw in the collar that goes from the earring to just under the nose.

2.

Add a circle for the clasped hands.

Draw in the hair shape and the upper cheek. Add the arms around to the clasped hands. Add the sides of her dress and the pattern on it.

Draw the crown on a slight angle. Add just a couple of eyelashes on each eye and some lines for her hair. Draw in her mouth and add the squiggly line for her fingers. Finish by drawing in the wavy line for the bottom of her dress.

4.

Queens wear shiny crowns with bright jewels in them. Notice the white spots that highlight her crown. You can make these with correction pen or white dabs of paint.

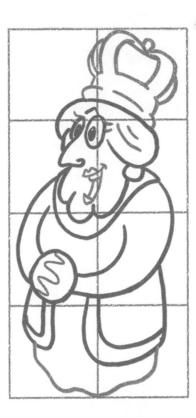

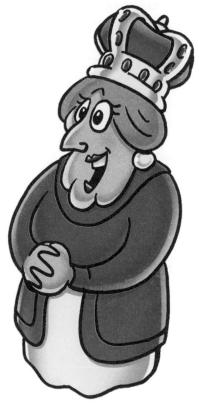

Superhero

Superheroes are a villain's worst enemy. They arrive just in time to save the day, foil the villain's evil plan and rescue the innocent victim. Superheroes have special powers that ordinary people only dream of. Here we have a classic superhero speeding to the aid of a citizen in trouble.

1.

Begin by drawing a grid with four equal squares going across and three down.

Notice his head shape. Both the henchman in this book and this superhero have a thick neck, large chin and small forehead, which makes them look tough. A large upper body with thick arms and small legs, which we are about to draw, adds to this effect.

2.

Add the cape and the shape for his chest going in to his arm. Notice the hand is very simple. Draw in the mouth to finish this stage.

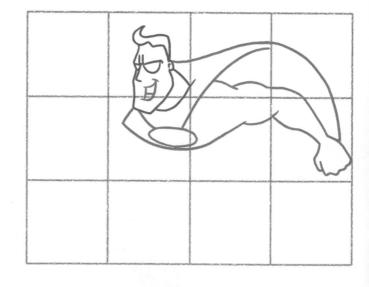

Draw in his other muscular arm getting thinner as it reaches his wrist. Draw his torso getting smaller as it reaches his stomach. Add the bottom of the cape.

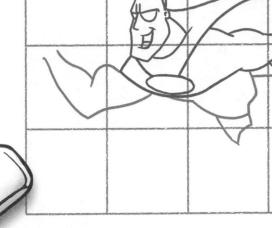

4.

Add his stomach muscle lines. As mentioned before, add the small legs. Study the clenched fist on his forward hand. Finish with his pupils in his eyes. We have left his emblem bare so you can make up your own symbol. You could even use the first letter of your name.

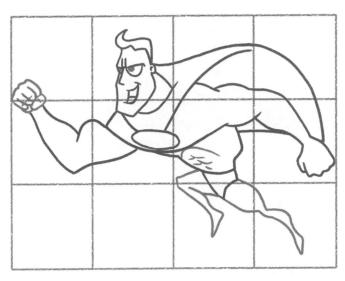

5.

Superheroes often have bright and contrasting colors and are seen in action poses. Do you think you could recreate this superhero in different poses?

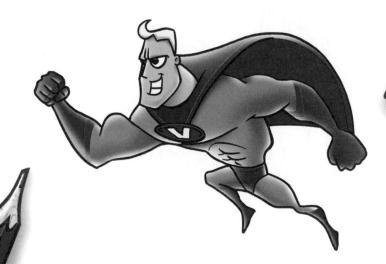

Ant

Ants can be found just about

anywhere in the world, working together to collect food for their colony. The queen ant spends almost her whole life laying eggs. They use their antennae to smell. Ants don't have lungs! They breathe through tiny holes that they have all over their body.

1.

Begin by drawing a grid with four equal squares going across and three down.

Then draw the slightly coned shape for the head. Draw a smaller semi-circle for the middle part of the body. Add another circle behind that for the back part of the body.

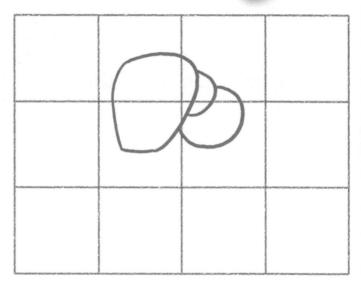

2.

Add the two eyes. on the first shape and the arch at the bottom of this shape. Draw in the shapes for the legs. Check that your drawing is in the correct place on the grid before you move on.

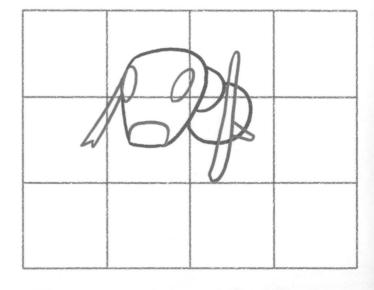

Here we add the antennae and some more parts for the legs.

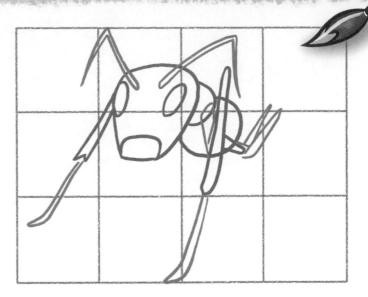

4.

Finish this drawing with the rest of the leg parts. Remember when outlining your ant to only go over the lines needed and erase all the construction lines.

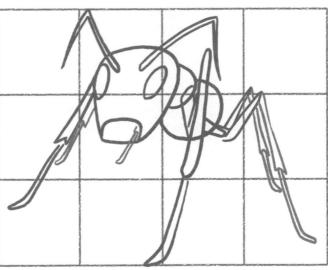

Here we have a "flea's-eyeview" looking up at the ant. We thought it would be fun to take a different angle on the ant because they are very small and usually looked upon from a great height. By taking a different view, we can make something look more interesting.

Wasp

Usually baby wasps will grow up inside a wasp nest, but some wasps lay their eggs inside other insects. That host insect

will slowly be eaten by the baby wasp as it grows up. Wasps generally eat other insects, but some species are vegetarian. Watch out for this fiendish character, it has a very nasty sting!

1.

Begin by drawing a grid with three equal squares going across and down.

Now draw the two smaller eye shapes. Add the head circle behind these. Finally add the tall oval behind the head shape for the body.

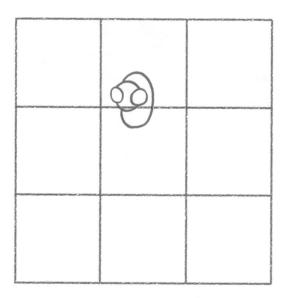

2.

Draw the wings coming out of the oval body. Add a thin waist piece and a large bulb for the abdomen and stinger. Check that your shapes are correct before moving on.

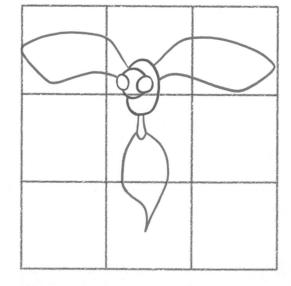

Here we draw some lines (or wireframes) for the six legs. The legs will be built around these. Draw a circle at the end of the middle set of legs for the hands. Add some lines for the wings. Finish with the details on the wasp's face.

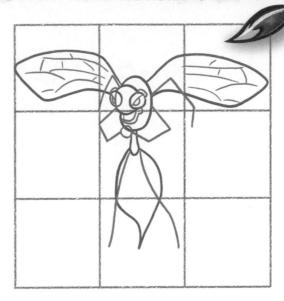

4.

Draw the top of the neck above the head shape. Add some razor sharp teeth. On the circle for the hand, add a zig-zagged line for the fingers. Build the legs in separate pieces around the wire-frame lines that were drawn in the previous stage.

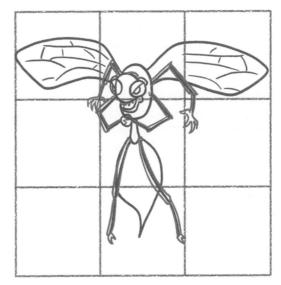

5.

Wasps are very bright and easy to see with their distinctive black and yellow markings. Did you know black and yellow are the two strongest contrasting colors?

Praying Mantis

The praying mantis is a master of disguise. It camouflages itself to look like a leaf while it sneaks up on its prey. It's called a "praying" mantis because its front legs are folded in a position that makes it look like they are praying. The mantis eats other insects and sometimes even small birds!

1.

Begin by drawing a grid with four equal squares going across and two down.

Then draw a triangular shape in the top left corner of the grid. Now draw the circular shape at the other end. Join these two shapes with a line. The thin body will be based on this line.

2.

Draw shapes for eyes on either side of the triangle. Draw around the long line and smoothly join it on to the body shape, coming to a point at the rear.

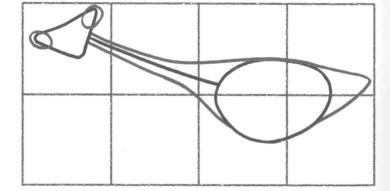

3. Add the front leg. Draw in the middle leg and the wing.

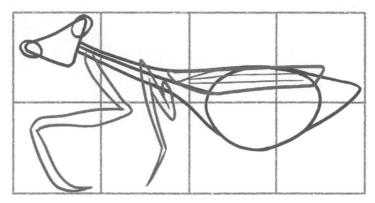

4.

Draw in the back leg and the body lines. Notice on the bottom they have been made to look slightly lumpy. Draw in the legs on the other side to finish.

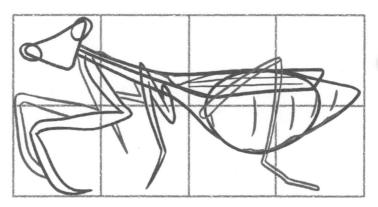

5.

The praying mantis is mostly green with a little gray on the side of its belly. You could draw it on a leaf or on a tree branch, as we have.

Ladybug

Begin by drawing a grid with three equal squares going across and down.

Now draw a roundish shape. Be careful to notice where the shape intersects points on the grid.

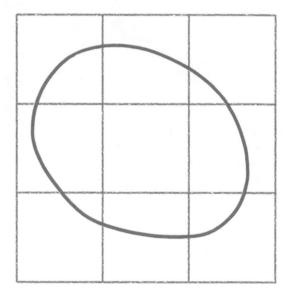

0

2.

Draw in some lines to divide the shape into the head and two parts of the ladybug's back.

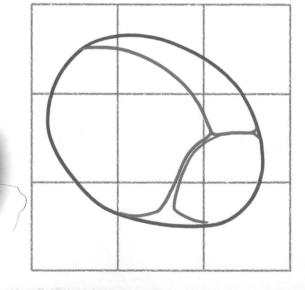

Add big eyes and feet. Draw in the large spots on the back and head to finish.

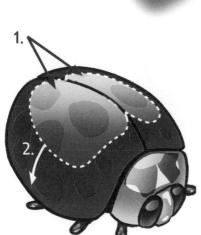

Artist Tip:

Here is a secret to great shading.

179

- 1. The dotted lines represent the section to highlight. You can also highlight the bug's head and eyes. This is colored much lighter than the rest of the bug. The highlight is stronger on one side and fades out a little at the other end.
- 2. Notice that at the edge of the highlight the red is darkest. This color then fades into a brighter red, as it moves away from the highlighted section. This is the same for the body, head and eyes with their colors.

4. Color in your ladybug. Notice how there is a little bit of color on the feet.

Dragonfly

Dragonflies are a flying insect and come in many different colors. They live near a source of water, where they lay their eggs. Although they are a large insect, they don't sting or bite humans. The dragonfly eats mainly smaller insects such as mosquitoes and midges. Some dragonflies can fly up to 40 miles per hour!

1.

Begin by drawing a grid with three equal squares going across and down.

Next draw the shapes for the head and the body parts. Check these are positioned in the correct place on the grid.

2.

Add the wings on the correct angle. Draw in the tail to finish this stage.

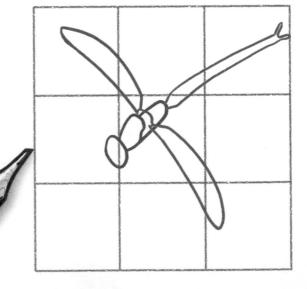

Define the face by drawing in the eyes. Add the front wings and the short strokes for the legs behind the eyes.

4.

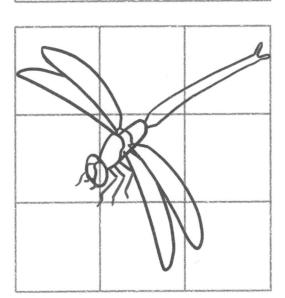

Finish off by drawing the rest of the leg parts and the mouth parts.

Here we have added some subtle lines for the veins in the wings. Because the wings are thin, drawing these in black would have made our wings appear too dark and heavy.

Butterfly

There are about 17,000 different types of butterflies. Most adult butterflies only live for one or two weeks. Their mouth is like a straw so they can reach down into flowers and feed on the nectar. Their mouth is rolled up when they aren't eating. Some butterflies can taste with their feet!

1.

Begin by drawing a grid with four equal squares going across and three down.

Then draw a stretched semicircle and oval near the bottom of the grid.

2.

Add the shapes for the face and the eyes. Draw in the shapes for the wings to finish this stage.

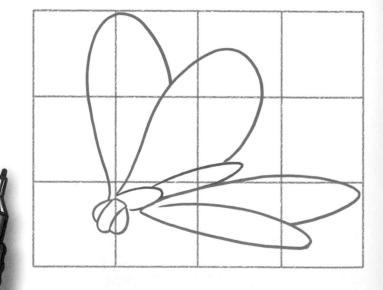

Add the mouth-straw at the front of the face. Draw in the legs and underpart of the body. Draw lines with arches in them on the wings.

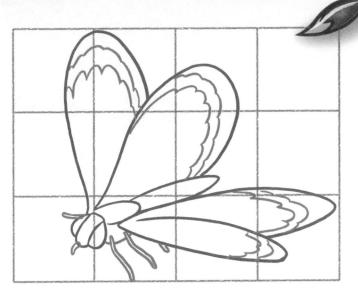

4. W Add the antennae from the top of the head. Draw in lines on the wings to meet the points of these arches drawn in the stage 3.

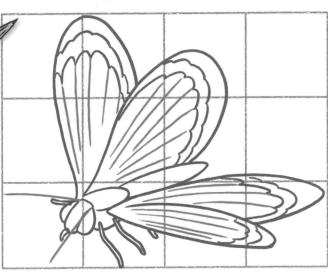

5.

Once you have outlined your butterfly, you may like to color it with many colors. Butterflies are one of the most colorful insects in the world.

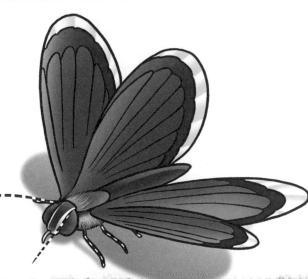

Blowfly

Blowflies are big noisy flies. They are commonly found at barbeques and picnics trying to land on your sausage or swim in your drink. Other favorite places to hang out are the garbage bin or the nearest cow pat. Blowflies are typically unclean, slow and dopey.

1.

Begin by drawing a grid with three equal squares going across and down.

Now draw a large circle for the body. Add the eyes and face shape above it.

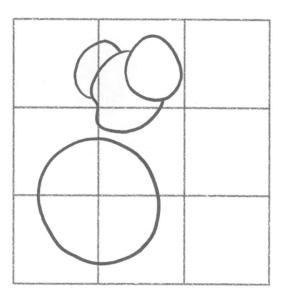

2.

Cut the eye shapes in half with a slightly curved line for eyelids. Draw in a curved line for the pupils. This makes the blowfly look dreamy. Add the rest of the body and the wings on either side.

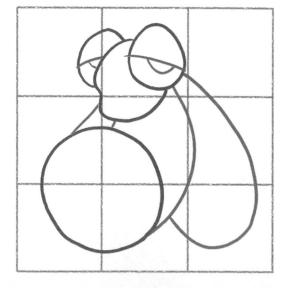

Here we make the eyelids thicker by drawing slightly larger lines around the outside of the eyes. Next add the small mouth parts. Finish this stage with the thin arm and up-turned hand.

4

Add two more sets of arms below the first set. Put in some veins on the wings. Use short strokes and dots around the body and face to make the blowfly slightly hairy.

185

5.

A dull, dreary blue-gray color best suits a fly. This highlights the dullness and greasiness of his character.

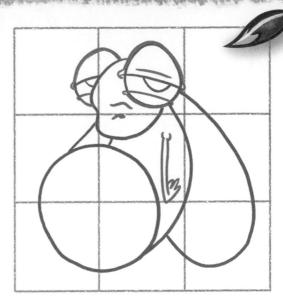

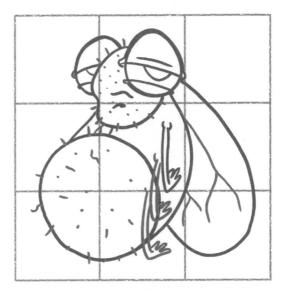

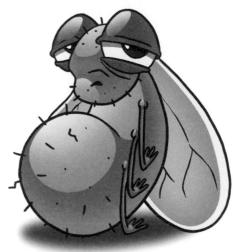

Bee

In the bee world, the queen bee is the boss. A worker bee's job is to collect nectar from flowers. They use the nectar to make honey. They all work together to get the job done. Only the female bees can sting and collect honey. The buzzing noise that bees make is their wings flapping really fast.

1.

Begin by drawing a grid with four equal squares going across and three down.

Next, draw the shape for the head. Add the next two shapes, being careful to take note of the size of them.

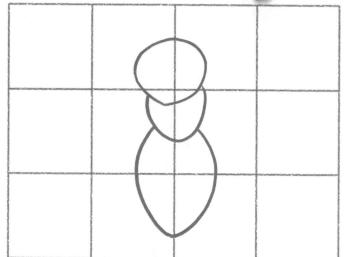

2.

Draw the eyes on the edges of the head shape. Add the folded antennae. Draw in the bucket to finish this stage.

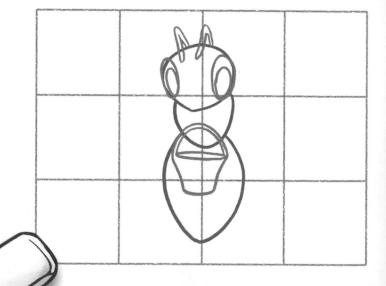

Here we add the arms holding the bucket. Next, draw in the legs, starting at each side of the bucket. Draw in the shapes for the wing movement. Add the highlight on the eyes to finish.

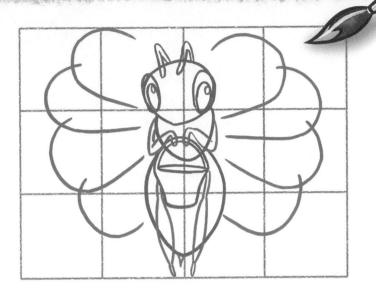

4

Add the second set of hands and elbows near the bucket. Finish with the movement lines on the wings.

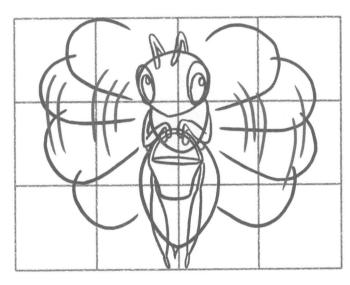

5.

To make this bee look feminine, large eyelashes have been added. This is an easy way to make something look female. Try it with your own drawings.

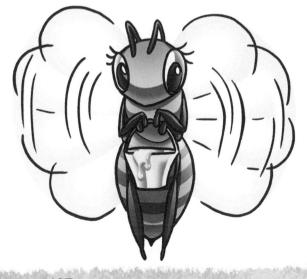

Mosquito

Mosquitoes are attracted to sweat, warmth, light, body odor and the air we breathe out of our lungs. They breed in still water – anything from still creeks to puddles. Only the

females can bite and when they do, they leave little, itchy red marks. They also have an annoying buzzing sound, which is heard after you turn your bedroom light off.

1.

Begin by drawing a grid with four equal squares going across and three down.

Next, draw the shapes for the head, body and tail. Check to make sure you have them in the correct places on the grid.

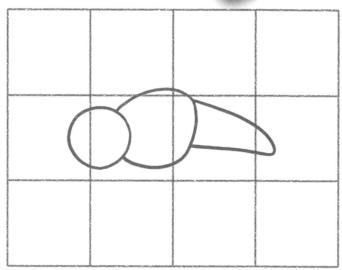

2

Draw in the eyes and mouth. Add the napkin. Draw in the wings to finish this stage.

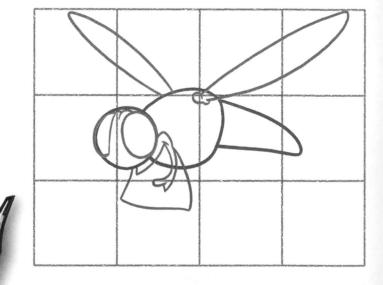

Draw in the swirl on the large eye. Add the eyelid for the other eye. Draw in the snout and circles at the base of the eye. Draw the chiplike hairs on the back. Finish with the lines on the wings.

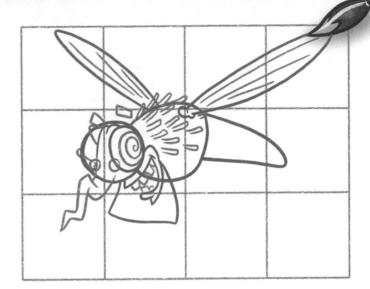

4.

Draw the front legs with the hands and cutlery. Add the pupil in the further eye. Draw the rest of the legs on both sides. Add some rings around the tail to finish.

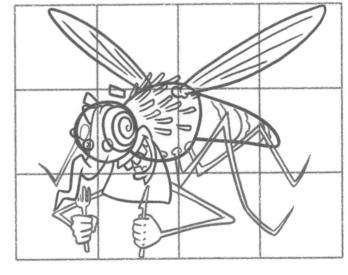

5.

Mosquitoes are a menacing insect. What better way to capture this characteristic than with a menacing looking mosquito. Good thing they're easy to swat, huh?!

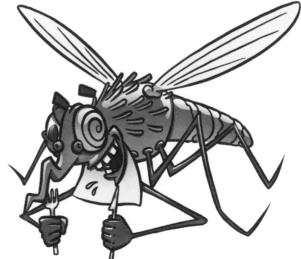

Grasshopper

Some grasshoppers will only eat certain types of leaves, while others will eat almost any type of plant. Grasshoppers sometimes eat so much that a farmer can lose all the crops that he has been growing. Grasshoppers can fly, but they are best known for their ability to jump really high and far for their size.

1.

Begin by drawing a grid with four equal squares going across and three down.

Study these shapes carefully in order to recreate them on your own grid. Begin by drawing in the head, eye and mouth shapes.

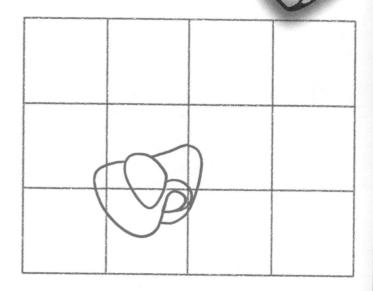

2.

Draw in some lines for the eyelids and the eyeballs. Add the eye shape on the other side of the head shape. Draw the wings and add the lines for the underbelly of the grasshopper.

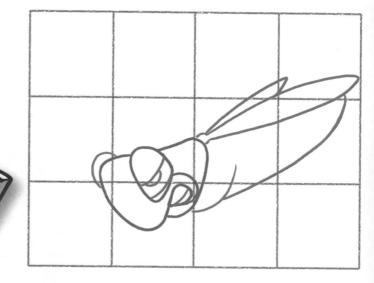

Insects

3.

Draw the similar two front legs and their shoes. Draw in the large back leg and shoe to match.

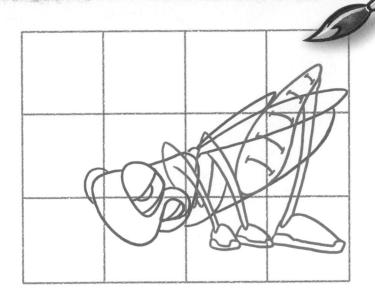

4.

Add the antennae on the head. Draw the legs and shoes on the opposite side. To finish, define the laces on the shoes.

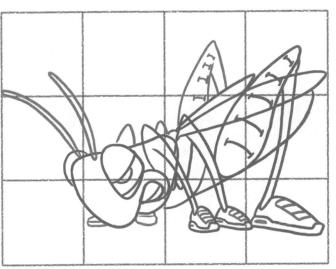

Because grasshoppers can jump so far, we thought it would be fun to enter him into the Cartoon Insect Olympics. What other insects can you think of to join in these games?

Insects

Published by Hinkler Books Pty Ltd 45–55 Fairchild Street Heatherton, Victoria, 3202, Australia LONGJUMP COMPETITION

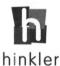

© Hinkler Books Pty Ltd 2006, 2008, 2009, 2013 Written and illustrated by Damien Toll With thanks to Jared Gow Cover design by Sam Grimmer Prepress by Graphic Print Group

All rights reserved. Without limiting the rights under copyright above, no part of this publication may be reproduced, stored in or introduced into a retrieval system, or transmitted in any form or by any means (electronic, mechanical, photocopying, recording or otherwise), without the prior written permission of Hinkler Books.

ISBN: 978 1 7436 3383 0 Printed and bound in China